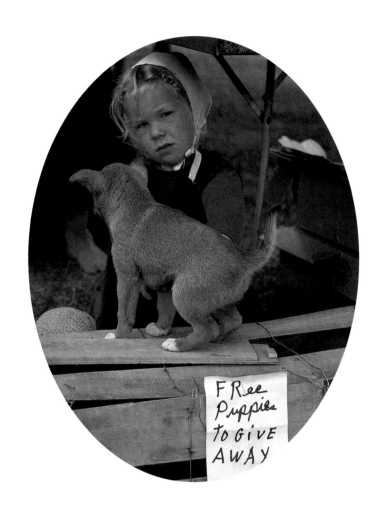

FRee
Puppies
TO GiVE
AWAY

AMISH CHILDREN

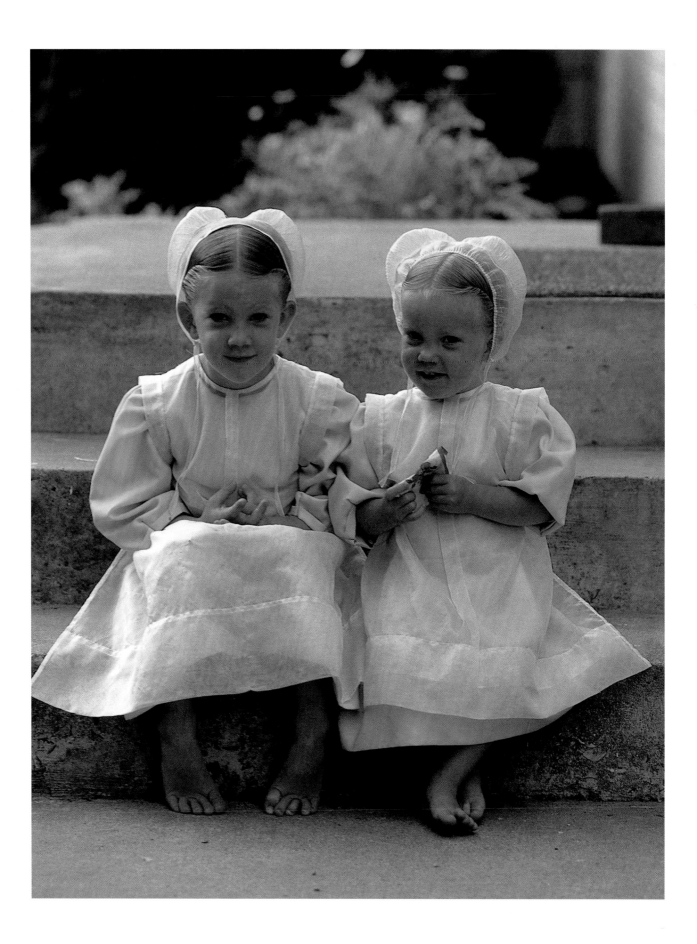

AMISH CHILDREN

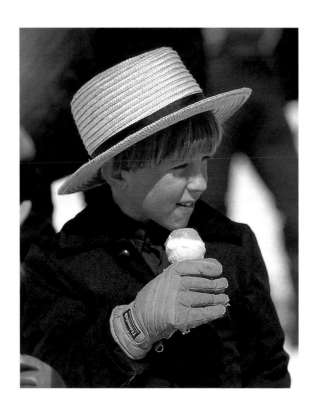

Phyllis Pellman Good
photographs by Jerry Irwin

Good Books

Intercourse, PA 17534
800/762-7171
www.goodbks.com

Acknowledgments

I am grateful to those members of the Amish community who allowed me to interrupt their days and evenings and then patiently answered my questions. I am also grateful to Steve Scott for gracefully sharing from his extensive knowledge.

Thank you to Pathway Publishers (Aylmer, Ontario) who publish *Family Life* and *Blackboard Bulletin*, the sources of the Amish children's writing and several comments from Amish parents and grandparents.

—Phyllis Pellman Good

Design by Dawn J. Ranck

AMISH CHILDREN
Copyright © 2000 by Good Books, Intercourse, PA 17534
All photographs in this book copyrighted © by Jerry Irwin / The People's Place. All rights reserved.
International Standard Book Number: 1-56148-380-X
Library of Congress Catalog Card Number: 00-059633

Library of Congress Cataloging-in-Publication Data

Good, Phyllis Pellman
 Amish children / Phyllis Pellman Good ; photographs by Jerry Irwin.
 p. cm.
 Includes bibliographical references.
 ISBN 1-56148-380-X
 1. Amish children—Social life and customs. 2. Amish children—Social conditions. 3. Amish children—Pictorial works. I. Title.
E184.M45 G67 2000
305.23—dc21
 00-059633

TABLE OF CONTENTS

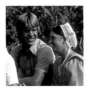
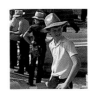
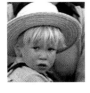

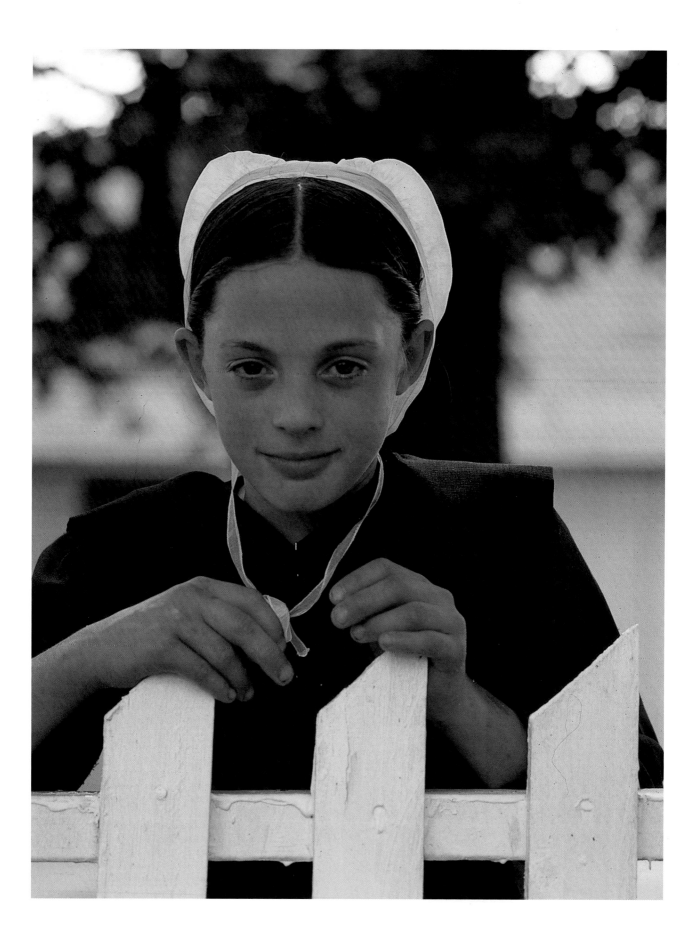

BELONGING

When a child is born to Amish parents, that infant Emma or tiny Jonas enters both a family and a community. This child's rearing rests upon its parents, but not without the strong interest of their extended family—and their Amish peoplehood.

The Amish have large families by 21st century North American standards; seven children is the average. Each child is treasured, although that deep value and love are expressed in language that may not be fully understood by the larger world.

In fact, many Amish have two primary

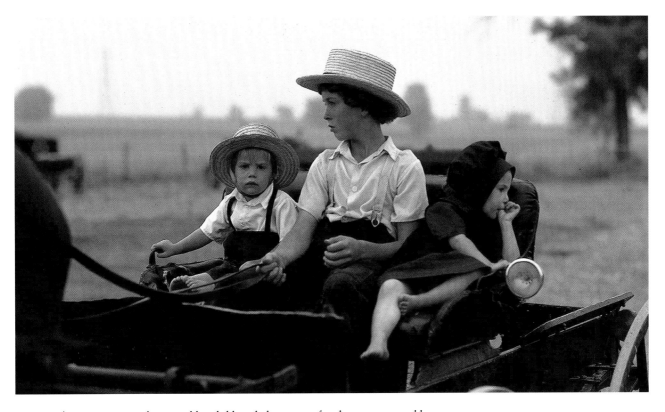

(Above): At an early age, older children help to care for their younger siblings.
(Left): Amish children are taught modesty, humility, and respect for others.

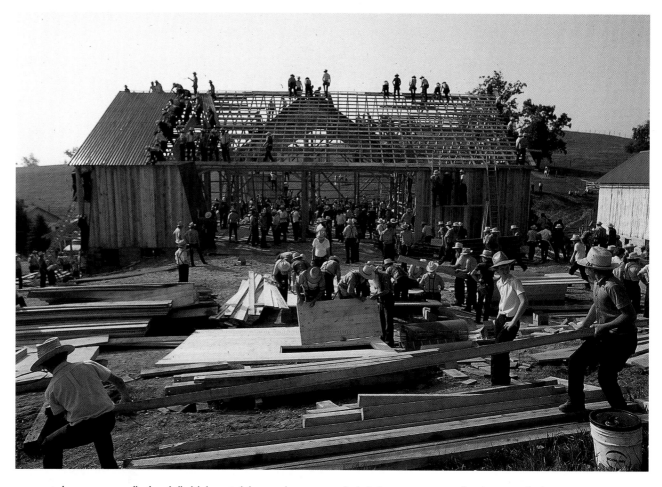

A barnraising calls for skilled labor. Adolescent boys are included, but are given tasks that match their experience.

reasons for living as they do: to be faithful to God and to be an example to their children. Childrearing—and growing up Amish—belong to the very soul and sinew of being Amish.

Children born to Amish parents become part of a highly intentional *community*. They are not automatically members of the Amish *church*. Joining the church requires a decision by each individual, usually made in the late teens or early 20s. Life until then is full of learning to work, dis-

covering how to be a responsible and contributing part of the Amish world, and finding a balance between the duties of life and its true pleasures.

A Community Effort

One cannot raise Amish children alone. It is the effort of a whole community, intently devoted to a way of life. Nurturing children is one of the strongest factors in Amish fathers and mothers choosing to work at home; it is the reason for the

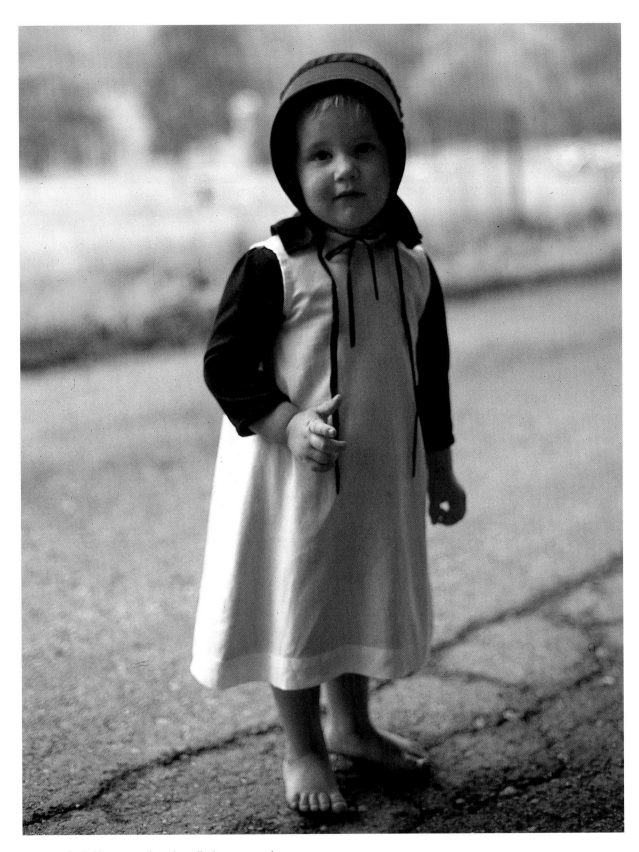

Amish children are often friendly but reserved.

3

Amish community's investment in its school system; it is a primary force fueling the identifiable way in which Amish adults live their lives.

That children feel they belong, that they know they have a place—those principles guide all Amish parents and grandparents, but also Amish schoolteachers and ministers and neighbors.

Children are not the center of the Amish world. But they do hold a certain position of sanctity for Amish adults, not too distant from their Christian faith and their devotion to faithful living. One older Amish mother reflected, "Our children's upbringing is still, and probably always will be, the most important part of our lives."

"The greatest need is to be a good example," expressed a grandfather.

Amish children do not steer their parents. Amish adults do not fawn over or dance for their youngsters. Yet these children have their parents' attention in a most fundamental way. Mothers and fathers structure their responsibilities so that they can be present daily and consistently. They strictly limit their time away from home, usually taking one or more children along if they need to go to the store or an auction. When they

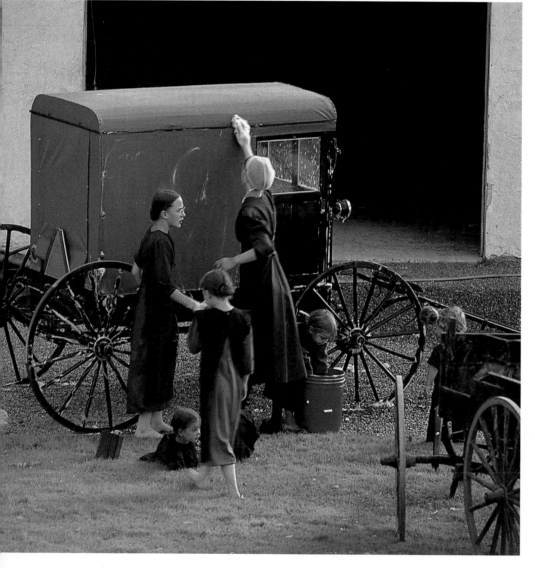

Buggies get dirty, too.

4

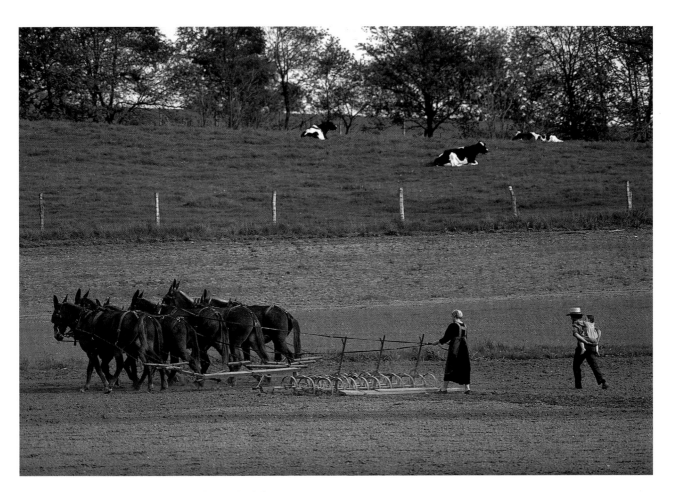

One serious team is followed by a playful one.

Common First Names Given to Amish Children

GIRLS

Sarah	Lena		
Naomi	Esther		
Ruth	Nancy		
Mary	Lydia		
Katie	Barbara		
Sadie Mae	Emma		
Rachel	Miriam		
Rebecca	Anna Mary		
Lizzie	Mattie		
Fannie	Sallie		
Anna			
Annie			

BOYS

Jonas	Melvin
Joseph	Leroy
Daniel	Reuben
Samuel	Aaron
Benuel	Levi
David	Isaac
Abner	Emanuel
Amos	Eli
Jacob	Henry
John	
Gideon	
Stephen	

In many families, grandparents live nearby, creating many occasions for three-generation activity.

take a break from work, they make it inter-generational fun, from turning homemade ice cream in the crank freezer to visiting aunts, uncles, and cousins.

Ever-Present Parents

Nothing, Amish parents believe, can substitute for their own direct and constant involvement with their children, and they practice that conviction fervently. Most Amish families eat three meals a day together. *Datt* (the Pennsylvania Dutch dialect word for "Dad") and *Mamm* (the Pennsylvania Dutch dialect word for "Mom" or "Mother") work at home on the farm. If they aren't farmers, *Datt* likely works in a machine or cabinet shop across the yard or within the neighborhood. In certain areas, as farmland becomes less and less available to the swelling Amish population, some Amish men take jobs in recreational vehicle factories or with carpenter gangs. They leave home early in the morning and don't return until late in the

afternoon, leading one Amish leader to reflect, "The lunch pail is one of the great threats to the Amish community."

From late August through the end of May, the schoolchildren miss the noontime meal with their families. But then they are in the company of other Amish children, in a world nearly as familiar and secure as home.

Days are full for these children. The littlest ones stay in the house or garden with their mother, free to play but never out of view in the sprawling kitchen or yard. Older preschool youngsters may circle between house and barn, but not without the parents knowing which of the two of them is responsible for the children's activities and safety. School-age sisters and brothers often monitor their younger siblings, keeping them happy and occupied, while savoring the trust that task requires.

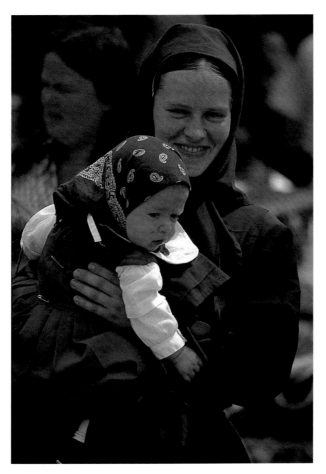

Families are large, but parents and children form tender bonds.

Bought toys are minimal in this lively world. Yet within its boundaries are animals and ever-present playmates, and space for rolling and running, for chasing and games of pretending "House" or "Store" or "Farm."

A Well-Paced Life

These children's days are not given shape by a line-up of soccer games, piano lessons, camp, or play groups. Instead, the morning sun, chore-time twice a day, and the coming of evening set a structure for their time. So, too, do the days of the week and the seasons. In this largely rural, soil-anchored world, life follows the lead of the weather and the promise of productive fields and gardens. The children are not removed from this daily interplay with nature. They learn it, they begin to sense it and read it alongside their parents,

7

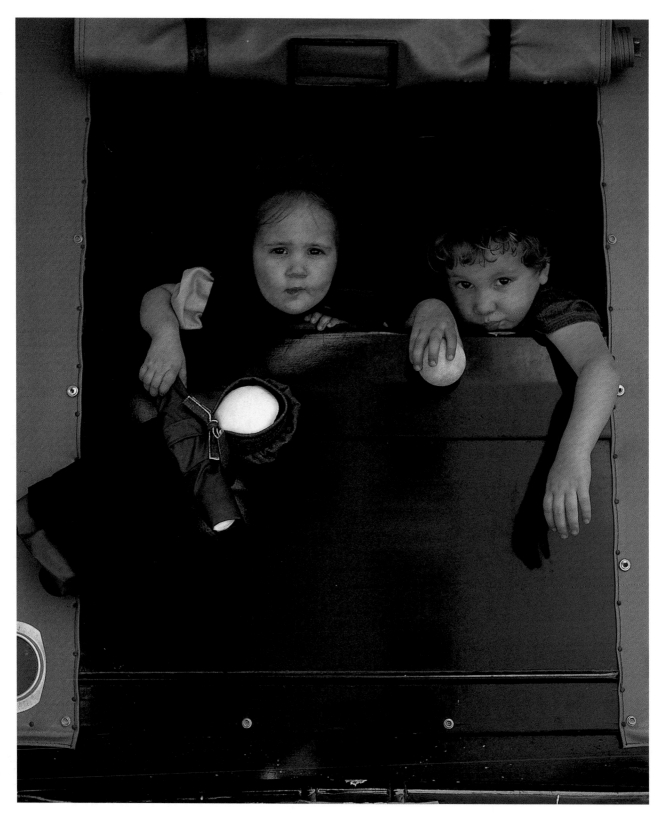

Children often ride in the back of the buggy, making contact with the traffic following them.

8

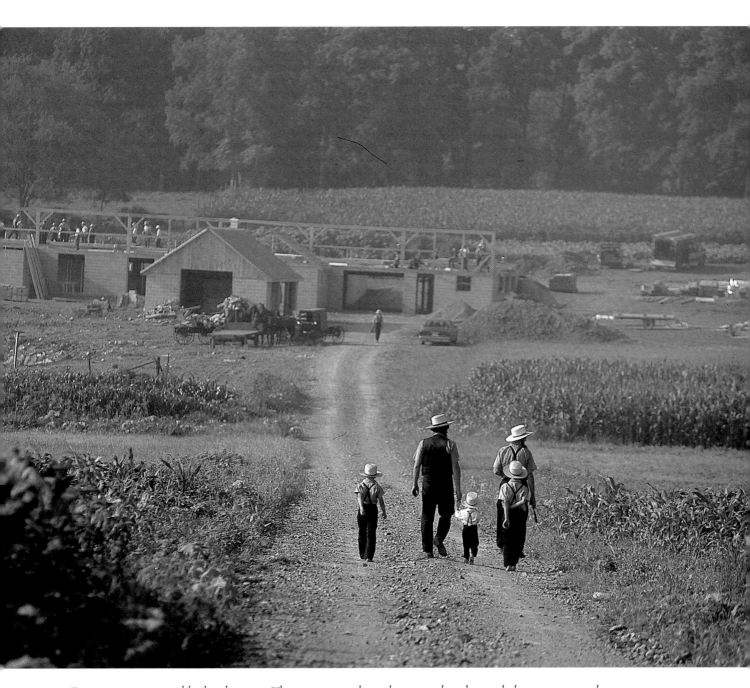

Barnraisings are neighborhood events. They are primarily work parties, but they include a strong social element, as well.

9

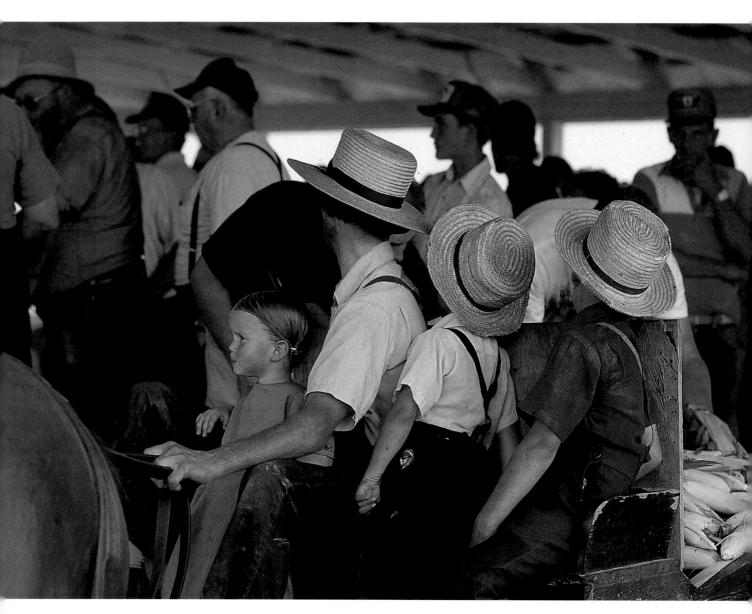

Datt *takes three of his youngsters along to the produce auction where he'll sell corn from the family's garden.*

who interpret what is happening while they go about their jobs, who point out the signals as they come, who invite their children to join them in responsive work.

Not dulled by television or computers, not distracted by telephones, these children grow to be keenly alert both to the natural environment and to the interests of their church community. They are fully occupied but not frenzied. They learn a contentment still available to those who focus their energies on the earth and its requirements, who devote themselves to giving and receiving from others. These are 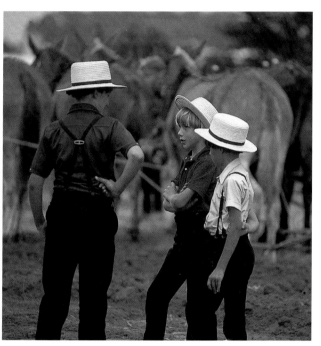 the lessons that the Amish know take a lifetime to learn and practice. These ideals require the reinforcement of a fully convinced community who live what they believe concretely and visibly. These are convictions best transmitted by immersion into the world which believes and propounds them.

And so the Amish speak a distinctive language, dress in distinguishing clothes, use and refuse particular technologies. They form and maintain their own schools and social events. They agree on and articulate boundaries for the safeguarding of their children, their families, their devotion to God.

In the end, they are largely successful. One Amish historian, regarded for honestly assessing his own people, believes that more than 80% of children who grow up in Amish families join the Amish church and choose to stay in the community. He immediately credits "the grace of the Lord and our strong beliefs."

Why Do They Stay?

His statistics and reasoning are echoed by a young Amish mother who quickly and with certainty expresses why she thinks so many Amish children decide officially to become Amish: "Most important of all is whether or not they feel they belong. That is helped if they feel close to their parents and their friends. And if they

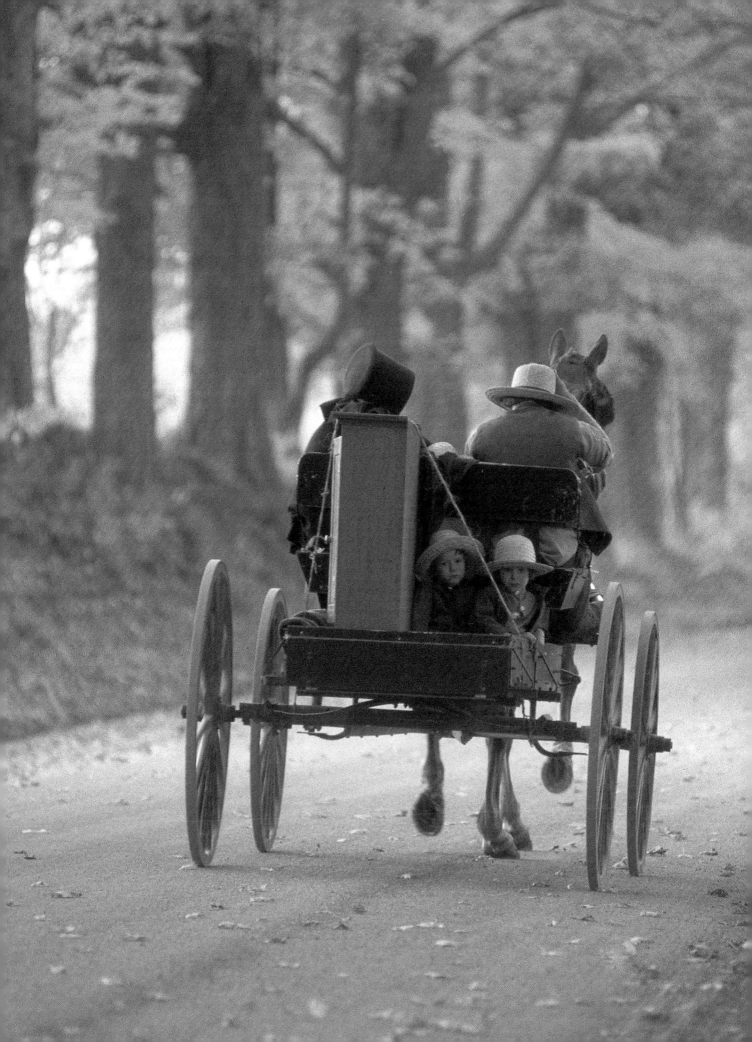

can respect the way that they were taught."

It is a childrearing approach with risk. Youngsters live nearly every hour of their first 15 years next to their parents, teachers, extended family, and members of their church district. These adults can't hide their weaknesses or doubts, nor can they keep secrets from such ever-present youngsters. It is a way of living and teaching that demands integrity. Furthermore, it must provide children with certainty and yet flexibility, and it must offer principles that can extend into yet unimagined territory where these children may one day find themselves. For the Amish world is changing.

One Amish leader believes that the need for young men to find jobs other than farming is good for all. "When I was growing up, I wasn't sure I wanted to be a farmer. Now, for people like me, there are more jobs available."

Within Lancaster County, Pennsylvania, the second largest settlement of Old Order Amish in the world, there are more than 250 Amish-owned shops, each employing an average of 15 Amish workers. Some have up to 60 staff.

The Amish work hard, yet they find a peaceful pace for their lives.

13

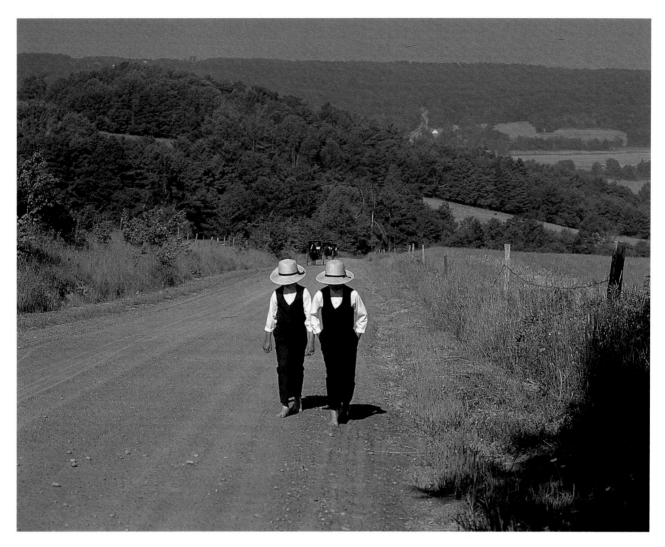

Following the several-hour Sunday morning church service, two boys take a break from sitting.

This represents healthy development for both Amish individuals and the Amish community, this leader proposes. "We have all these Amish employers who can be responsive to Amish social needs. They understand funerals and Good Friday and Ascension Day and weddings [all events that Amish persons either attend or commemorate by not working]. If the shop-keeper's daughter is getting married, the shop will be closed that day. We all benefit!

"These are some of the good fruits of our industrialization. We have people going to market, people in the quilt business. We can't all farm and the bishops see that."

With greater employment opportunities, the young people's circle of mentors and examples is also enlarged. The adults they

work with are still Amish, but an observant young person now has the possibility of seeing a somewhat different approach, of relating to other personalities, of undertaking a vocation different from *Datt's*.

The Risks

When the options increase, so do the dangers. Those few who do not join the church tend to be those who "get involved in some irreversible situation or who did not have a happy home," reflects one Amish leader. The "irreversible situation" may develop most easily for those "borderline boys who drive truck or work outside the Amish community. It may also be someone whose business becomes too successful," someone who allows the business to become the center of his life rather than the community.

"The goal is still to work at home, but you don't have to farm," sums up the leader. Opportunity has expanded, but it is carefully bounded by a guiding principle.

How firm is a grasp that is effective, but not too tight? It is a question lived by every Amish parent and church leader.

"What holds our young people?" asks an Amish grandfather. "The *support* they have from their parents and from the community. For myself, it was the closeness I felt to the group. I felt wanted. I belonged. As a teenager I saw I would have support for being an adult."

The effort begins in every home. But it is never a lone family's undertaking. For that, there is the community—with its many ways of reminding its members who they are and mean to be.

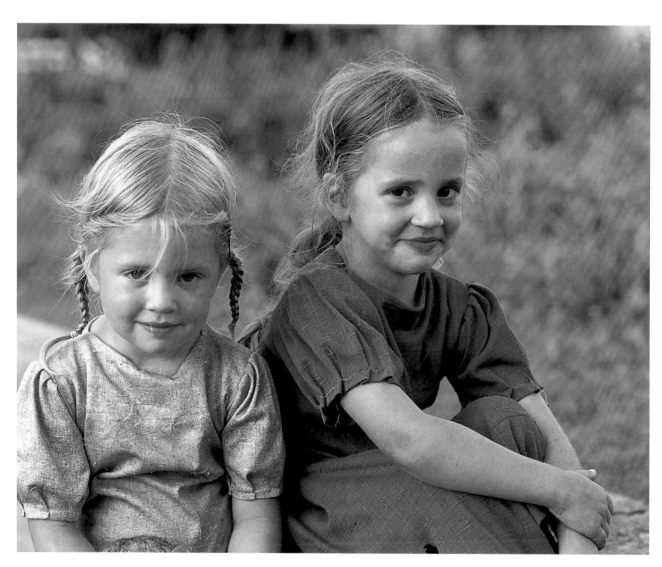

Children are dressed in simple, handmade clothing that immediately identifies them as Amish.

My Gratitude

I thank you, God, for everything—
The food that all the gardens bring.
Cozy beds and stoves that heat,
Nothing else which that could beat.

In the autumn, wondrous sights—
See the birds that take their flights.
Round the tree that squirrels go,
Various birds are flying low.

I thank You for our parents dear.
For many people far and near.
I do not know how that would be
To have no parents to care for me.

— **Grade 7, Age 12**
(Blackboard Bulletin)

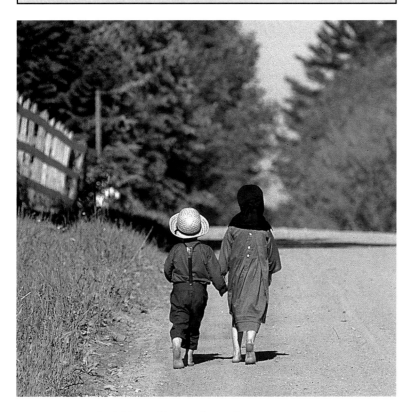

An Amish child is seldom without playmates.

17

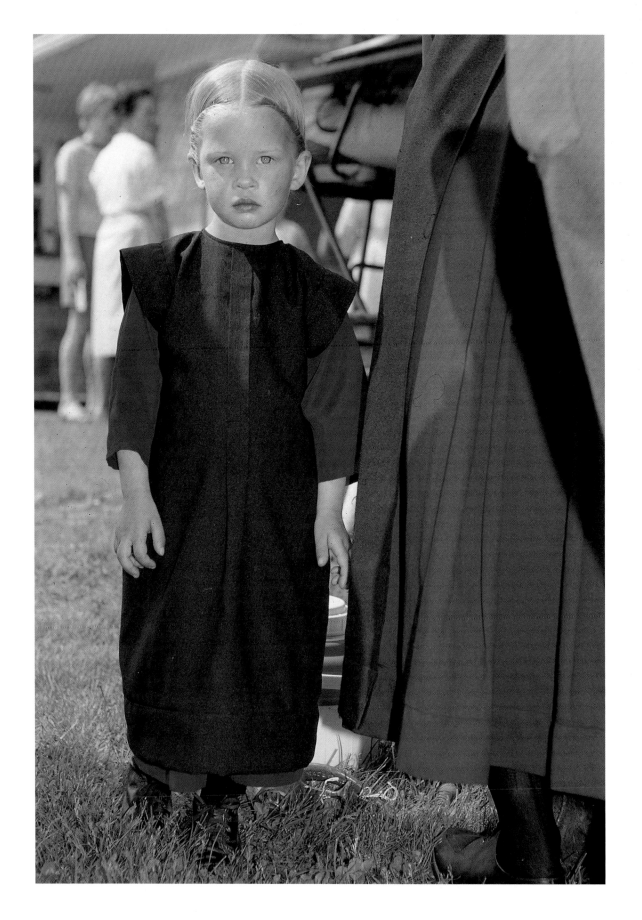

18

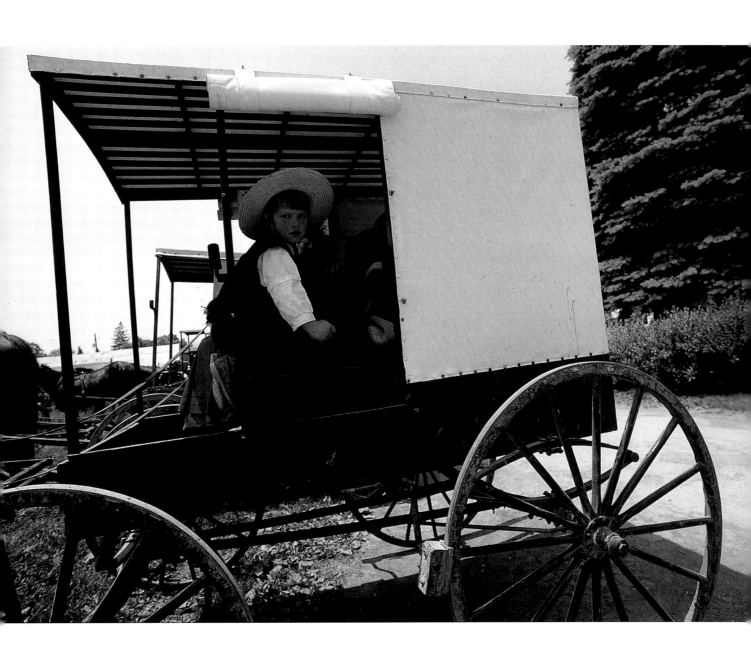

19

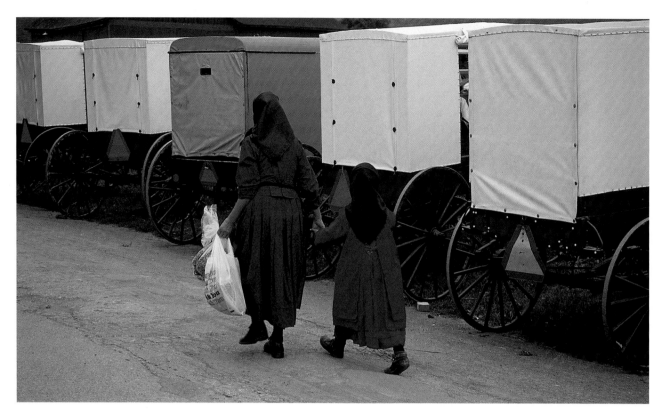

Three main Old Order Amish groups live in the Big Valley of central Pennsylvania. The Byler group drives yellow-topped buggies; the Nebraska group drives white ones.

Some Facts

The Amish are Christians who intend to follow what the Bible teaches in their day-to-day lives. In order to live their faith actively, they have forged a strong community which both supports and holds its members accountable to each other. In 2000, there are approximately 170,000 Amish (that number includes unbaptized children), scattered in 25 states and the Canadian province of Ontario.

Over time, church leaders have developed the *Ordnung*, a sort of agreement for living together

that provides specific expectations of Amish church members. The *Ordnung* blends with traditions and careful adaptations, producing quite detailed practices that take on particular meaning for members. For example:

- The Amish speak a dialect of High German, nicknamed "Pennsylvania Dutch." It is the language spoken at home, at social events, and while doing business with fellow Amish. Many children do not learn to speak English

until they go to
school.

"Dutch" provides a
glue and a social bor-
der, adding cohesive-
ness to the Amish
community and sepa-
rating them to a
degree from the larg-
er world.

- Capes and bonnets,
 straw hats and broad-
 fall pants announce
 instantly that their
 wearers are Amish.
 Distinctive dress pro-
 vides a visual short-
 hand identifying the
 Amish as different
 from the rest of socie-
 ty, as modest, as com-
 mitted to another set of
 principles, as members
 of a particular group.

From birth, Amish
children are dressed to
indicate that they, too,
belong to the Amish
world. In fact, dress
details change at speci-
fied times as children
grow up, becoming
markers of impor-
tance, especially to the
children who experi-
ence them as recogni-
tion of their maturing
by the community.

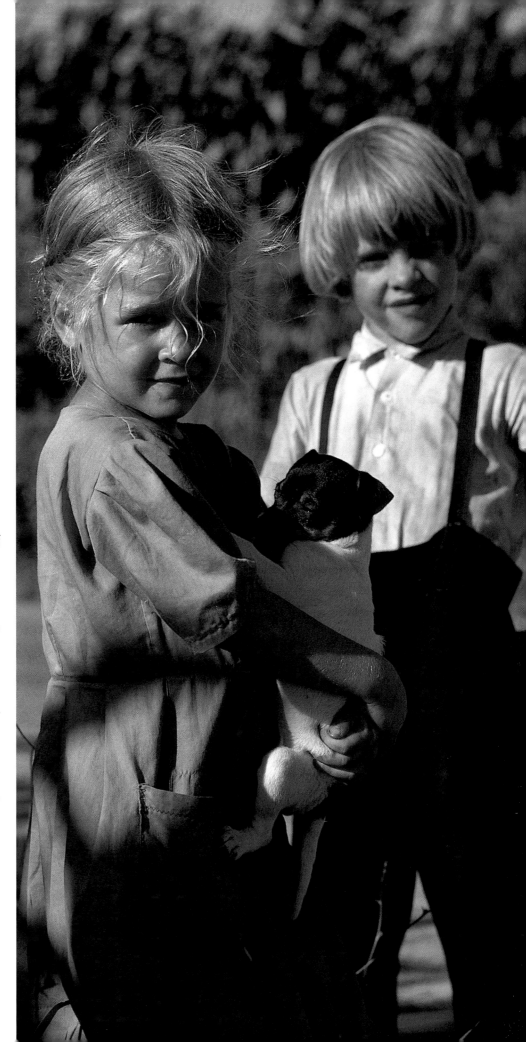

"My girls remind me when it's time to make the changes," confesses one mother with a smile, acknowledging the significance of the steps especially to the children. Small and detailed they may be, but these concrete practices are one more way the Amish community continually envelops its young.

Until age eight, an Amish girl in the Lancaster, Pennsylvania area wears a full-length apron over her dress that buttons in the back. When she turns eight, she begins wearing a waist-apron to school and a cape and waist-apron to church. At 11, she switches from having dresses that close with buttons to having them close with either straight pins or snaps.

A boy begins wearing a straw hat at age two. He starts dressing in pants with pockets when he turns three.

Between ages nine and 10 he moves from wearing a flat-crowned black felt hat in cool weather to wearing one with a ridged or "telescoped" crown. He keeps his straw hat for summertime use.

- At age nine, children are permitted to sit with their peers in church. "It's a milestone," explains one mother. Clearly the community trusts its children to have the self-discipline required to sit quietly (without toys, snacks, or conversation) on backless benches during its three-hour worship service. And the children feel dignified.

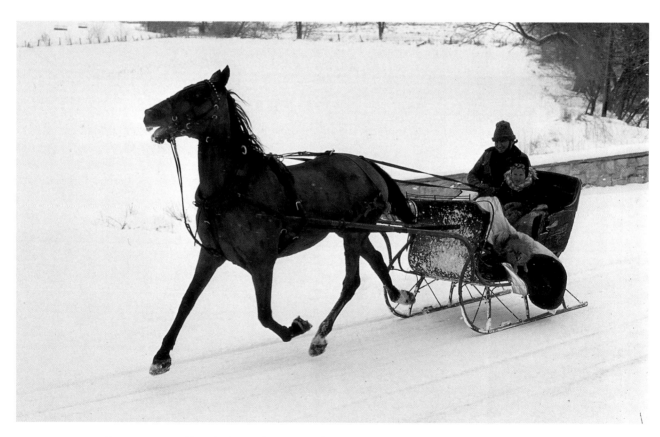

Snowy roads are not a problem for horse-drawn Amish vehicles.

- Traditionally, the majority of Amish babies are named for relatives. "It would be unusual for parents not to name their children after their grandparents," explains one mother. "It's an honor to our parents." Parents may select the name of a favorite aunt or cousin or sibling, sending respect between the generations and strengthening family connections.

 Those children who are not named for a particular relative are usually given one of the old-fashioned names common to the community. It is not uncommon to find a little Amos, Fannie, Emanuel, or Lydia running around an Amish homestead.

- Amish community life is secured by a host of social occasions. Sunday morning church services are always followed by the attending families eating lunch together. Quiltings and Sisters Days are outings for the women, and they go, accompanied by their preschool children. Barnraisings are men's work, but the women bring the food, and children attend as observers and sometimes helpers.

 Children join these events exuberantly, playing with their cousins and neighbors, and further establishing their place in this all-encompassing community.

 Typically, children attend weddings and funerals only of their immediate family members. Because both are held in homes and draw large adult audiences, children may go to an older sibling's home or to friends of their family

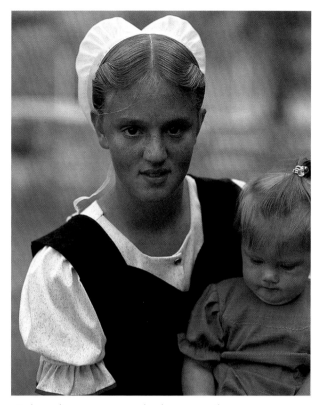

Girls and young women develop years of experience in caring for children.

while their parents attend the solemn event. They may not be at the place of honor, but they are still within the hands of the community.

23

Hummingbirds

Last summer we had hummingbirds visiting our feeder outside the porch window. They were quite tame, even sipping on a little nectar when we sat on the steps beside the feeder.

One day when I refilled the feeder I decided to do something different. I held the feeder, keeping very still. It wasn't long till one of the beautiful birds of the air landed on the stand, took a few sips, and flew off. But he soon returned.

My nephew David Byler had a hummingbird land on his finger. I think as long as we keep still, hummingbirds can be tame.

— **Esther Byler, age 13**
(Blackboard Bulletin)

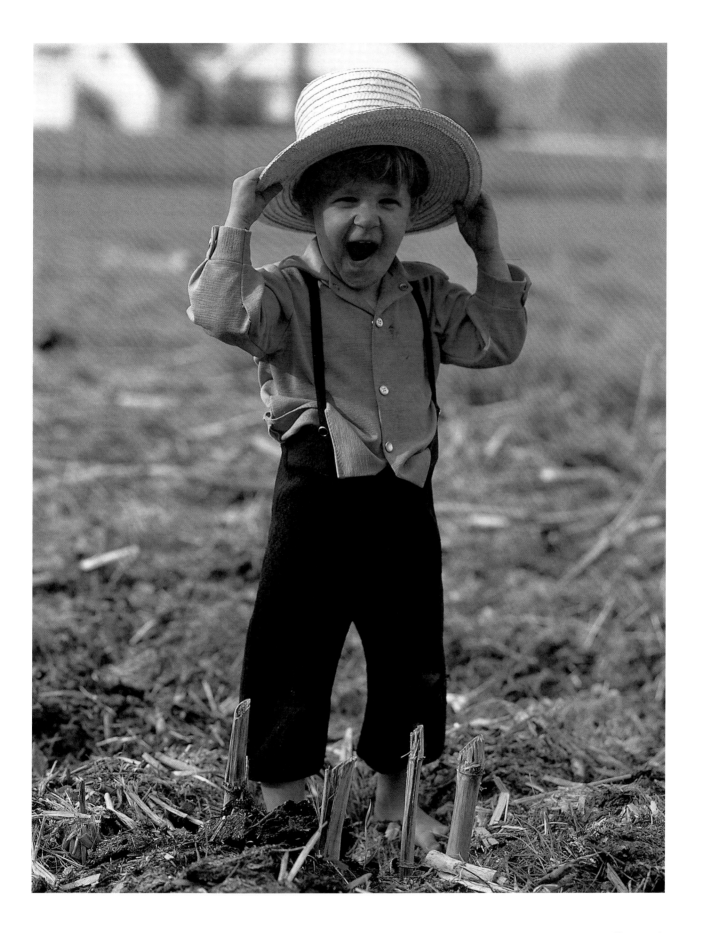

25

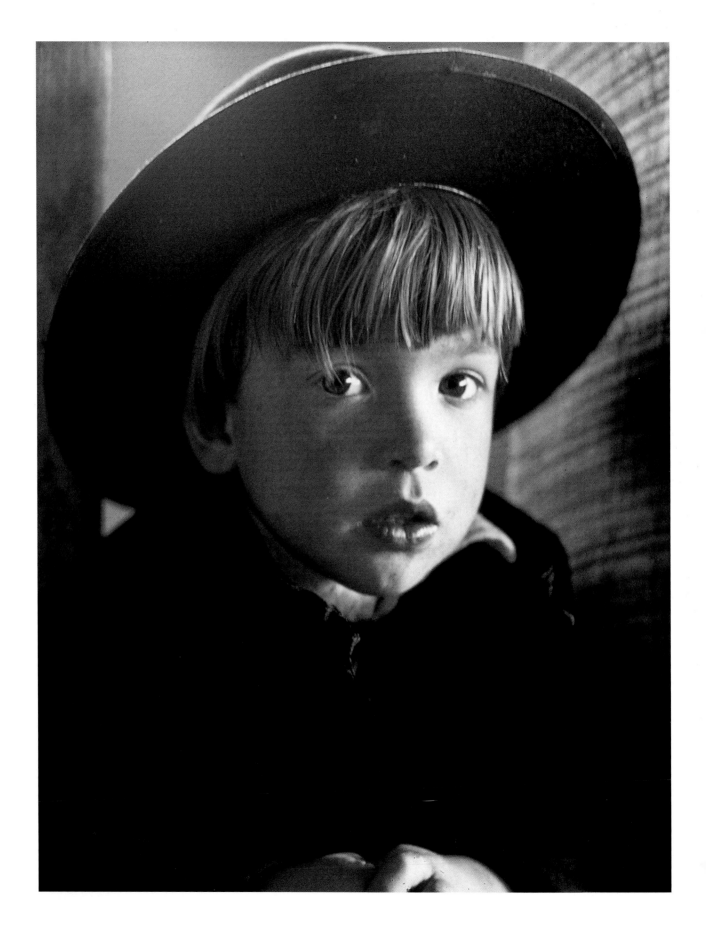

26

"THINKING" AMISH

The Amish do not live behind walls or on compounds. They do not refuse to do business with the larger world, nor do they turn down shopping at Walmart, nor stay off the roads. In fact, it is not unusual for Amish men to be members of their local volunteer fire company or for Amish women to take their broods to the local public library.

Exposing their children, albeit in a limited fashion, to the larger world requires double-duty by parents and church who

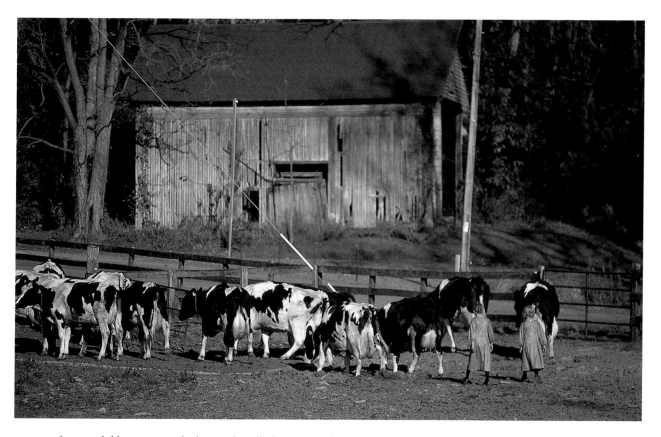

(Above): Children are taught how to handle farm animals.
(Left): Amish children often appear open, yet careful.

27

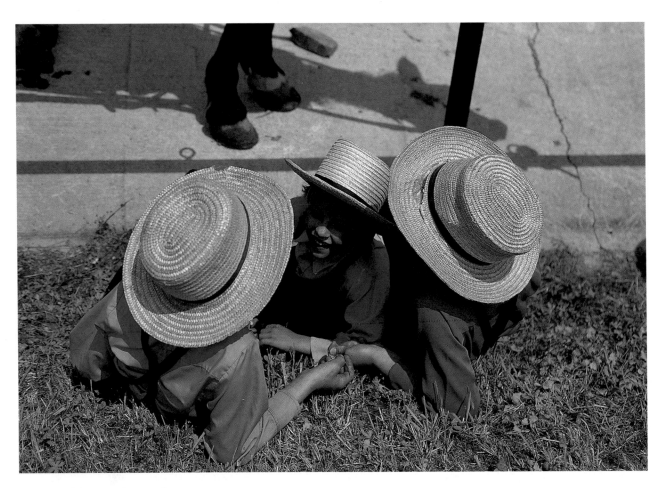

Buddies together. A choice pastime.

hope to have their children think and feel Amish. For being Amish is a comprehensive way of life that exceeds practicing the customs and speaking the language. It goes to the core of one's being, from which spring attitudes, reflexes, and, finally, peace with oneself, one's people, and one's God.

The Amish are looking for a different outcome than the world they live *in*, but are resolutely not *of*. The tools by which they accomplish their ultimate task, and then measure their success, are of a differ-ent currency than is customary in the larger society.

An Amish child is taught to think "we" and "us" rather than "me" and "mine." The Amish believe that they are complete as persons only when they are part of a community, only when they have joined with others, only when they have put the good of the whole ahead of the preferences of a tiny part.

This ideal demands footwork, tending, and practices that not only elude, but

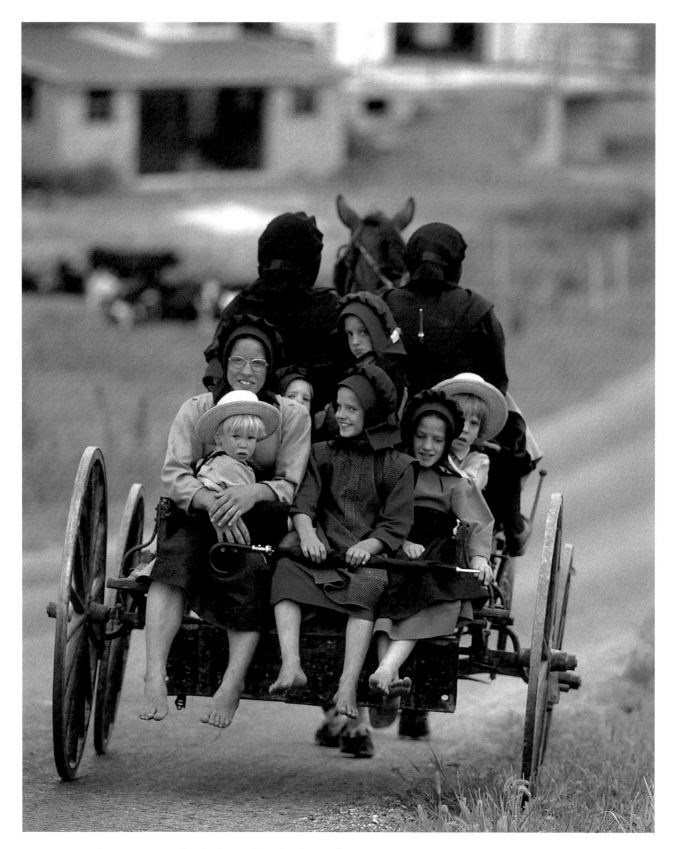

It must be Sisters Day, barely dimmed by the threat of rain.

revolt, many 21st century Westerners. The Amish speak of submission and obedience as high goals. They practice both, and they teach their children to behave accordingly.

Teaching Reverence and Obedience

Sitting in a rocker with four children spilling over her lap, an Amish mother speaks of the responsibility she feels. "The most important thing is to teach reverence for God. I feel terribly small to say that. The hardest thing is to teach the children obedience. One could go on and on. Of course I want to teach them respect for others."

Without a pause she addresses how she and her farmer husband undertake their most fundamental task. "We give lots of hugs in our family; we're very affectionate. We read together and sing together. We want to make a very strong bond with our children while they're young."

Amish parents believe they cannot succeed at teaching as they ought and want to without concrete, tactile, visible love. They know they cannot shape their children to understand that it is more essential to be a contributing member of the faith community than it is to excel as an

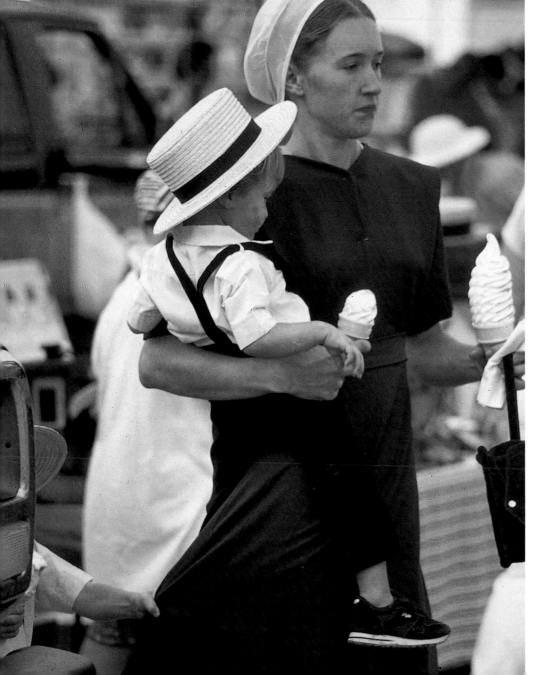

A mother, two children, and the reward for surviving shopping.

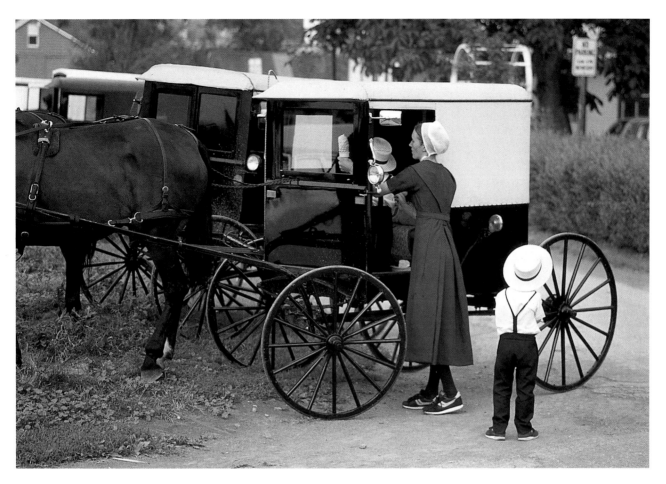

A still-intact ice cream cone will sweeten the drive home.

The Golden Rule

In English —
"... *whatsoever ye would that men should do to you, do ye even so to them* ... "
— **Matthew 7:12, the King James Version of the Bible**

In German —
"*Alles nun, as ihr wollt, dass euch die Leute tun sollen, das tut ihr ihnen auch.*"
— **Matthew 7:12**

In Pennsylvania Dutch —
"*Vass-evvah es diah havva vellet es leit doon zu eich, so sella diah du zu eena.*"
— **Matthew 7:12**

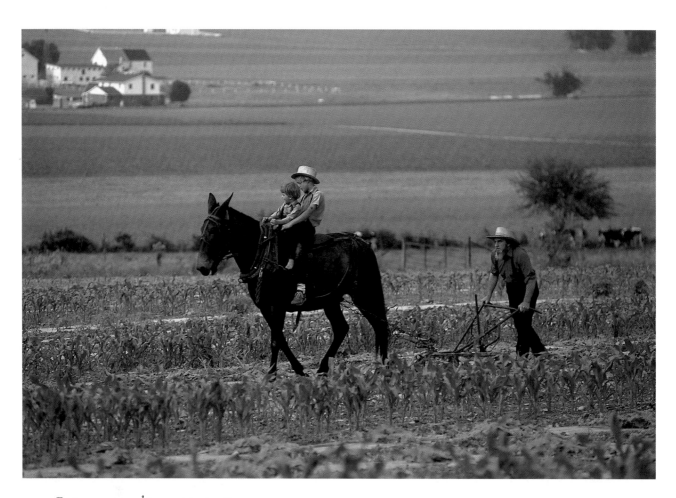

Part companionship, part instruction.

individual—without showing constant and abiding care and respect in return.

But this is not indulgent love. It is love delivered within discipline. It is work-alongside love.

The training begins early. "Patties down," spoken already to the child in the high chair, means "Put your hands in your lap (away from the food), bow your head, close your eyes, and pray." It is a moment of thanksgiving, offered at the beginning and end of a meal, in silence. Children are permitted no squalling, no demands, never mind their age nor their hunger. Instead, they are learning patience, thankfulness, reverence for God, and respect for the rest of their family around the table. And they will be fed bountifully!

Fitting Into the Family

They are also, in that same moment, experiencing being enjoyed and being in the quiet presence of their parents and their siblings. They are learning, as this

No makeup. No jewelry. No frills.

33

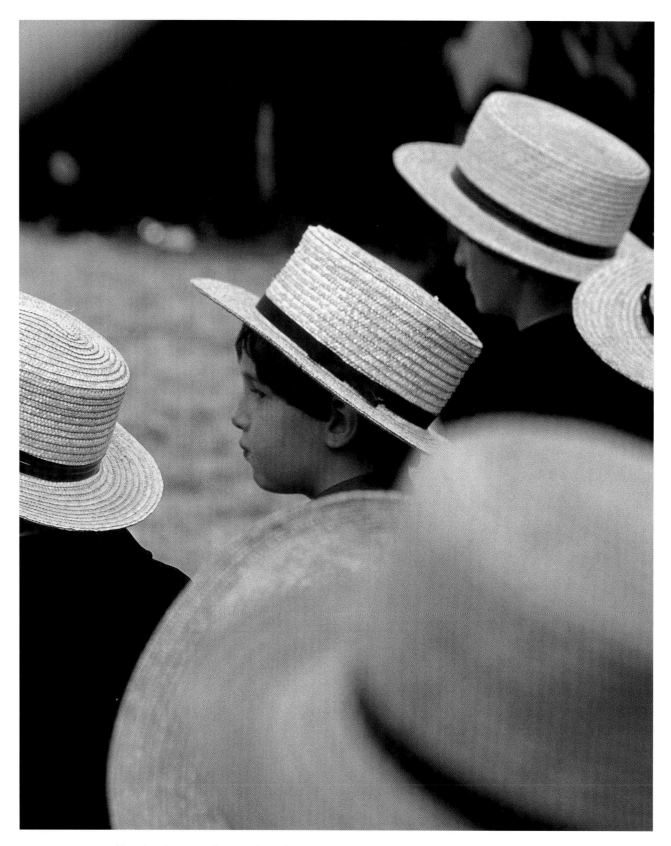

One may seldom be alone, yet the Amish world is scarcely ever frenzied.

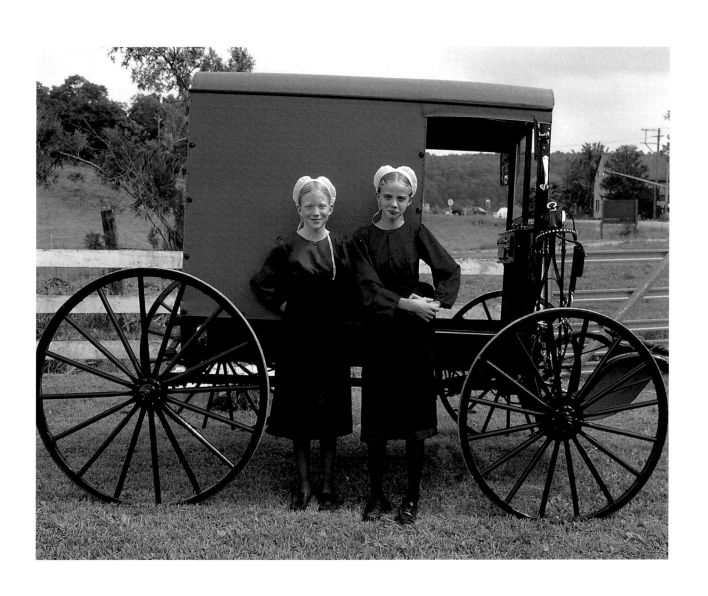

35

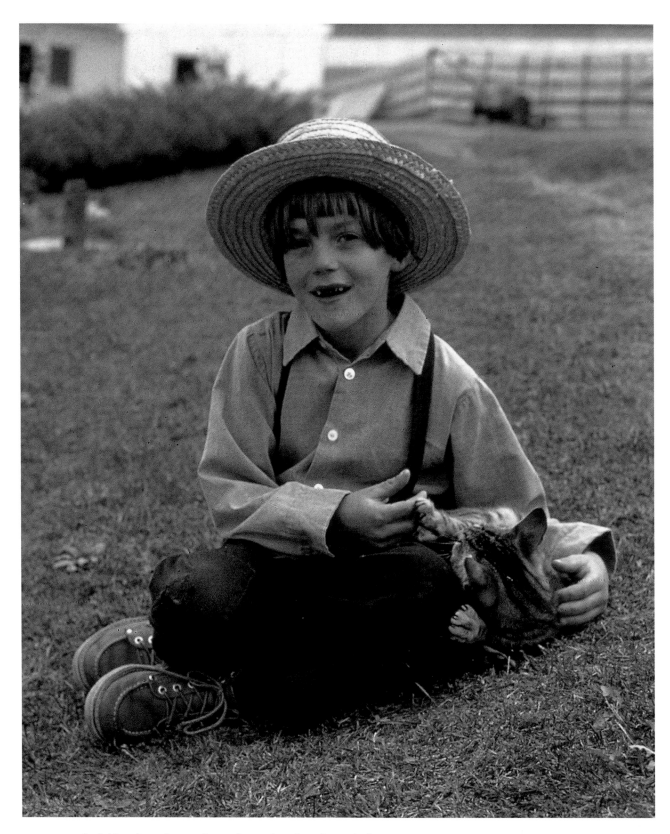

Amish children have few mechanical toys, but they do not lack space or pets.

scene repeats itself three times a day, that they belong here, one member of this tableful, taking turns in conversation, in sharing attention, and, eventually, in cleaning up after the meal.

Belonging, and bearing responsibility, become one act.

From the beginning, Amish children conceive of themselves as part of a whole. Being with others is all they know—from going along as babies to the fields with their parents to playing pretend "horse and carriage" as preschoolers with their constantly present sisters and brothers. They are taught to share as early as they learn to feed themselves, to walk, and to talk. While they may protest loudly or demand attention at the wrong time and place, they won't do it often. Reprimands are swift and clear; not harsh, but firm.

These children are being tooled to live cooperatively, not competitively. They are

Children fit into nearly every adult work situation.

part of a hardworking, and often prosperous, community which values humility, respect for others (especially leaders), and the wisdom found in group experience. Individual achievement is not cultivated or sought after, although every woman, man, and child is regarded as a contributing member of the community. There is no place for slackers here—nor for whiz kids intent on outstripping anyone within imagination.

Learning Responsibility Early

An Amish father and grandfather in his mid-50s needs no prompting about his deepest wish for his children and grandchildren: "I hope they get to heaven! But while they're here I hope they stay humble. I hope they lead useful and humble lives, that they learn to work and to be good marriage partners. That they learn to do with little and help a lot. We believe in

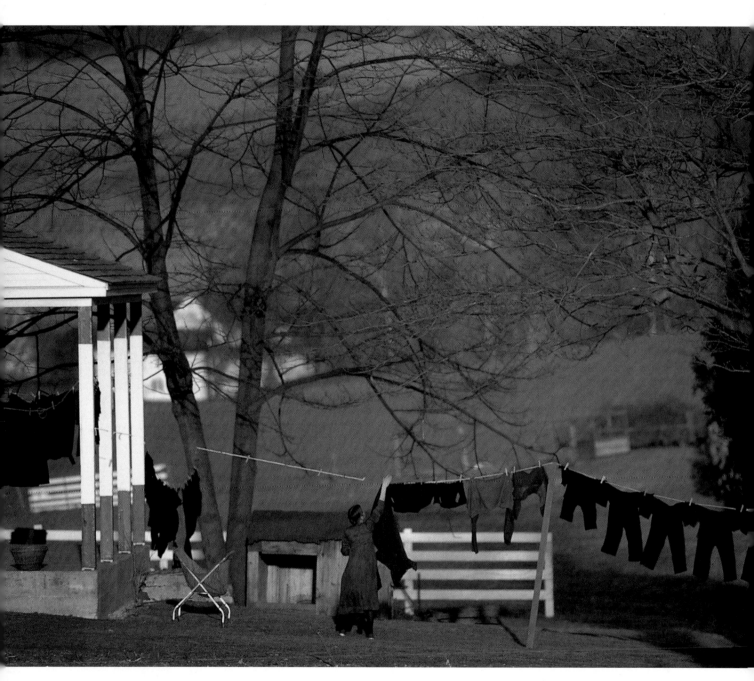

Children help with many of the steps in processing the family laundry—which is done without an electricity-powered automatic washer or dryer.

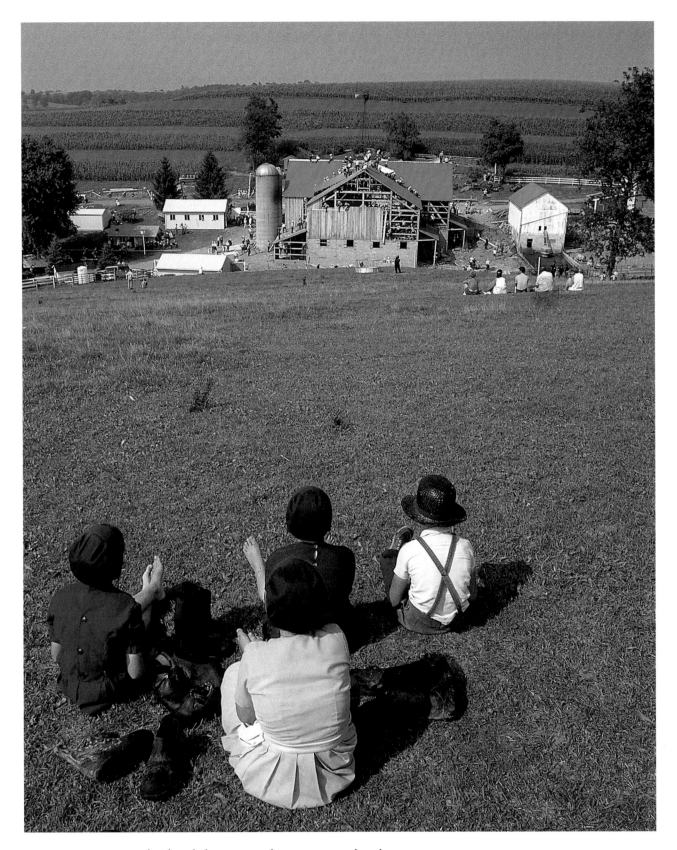

Barnraisings are hard work for some, and entertainment for others.

39

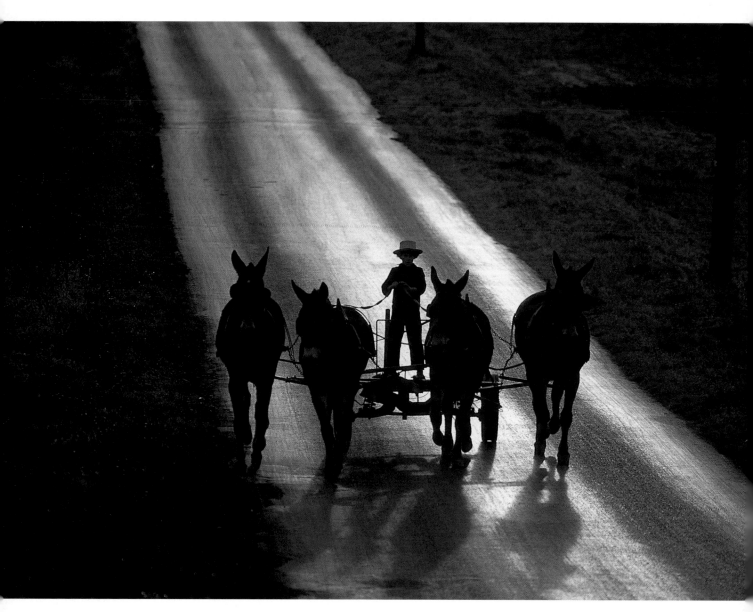

Adolescents shoulder major fieldwork responsibilities.

practicing the Golden Rule. We teach our children to help our neighbors—and not only Amish ones!—in time of need."

His wishes are not idle platitudes. The Amish, who do not carry health insurance and who offer a minimal form of property insurance to their church members, routinely pool resources to help fellow Amish with unusual medical bills. Barnraisings are not a myth. Men give up a day or more of work to help. A family hit by the loss of a parent receives help wherever needed—fields, house, or barn.

One Amish man who keeps record of Amish activity has statistics showing that "30% of our people's time is given to helping others." That impulse and consequent behavior begins to be cultivated in childhood.

With seven children between ages eight and 20 daily at her table, one mother remarks about the maintenance needed to keep everyone on track and to deal with disturbances. "First I'm apt to remind them that their attitude needs to be changed. If that doesn't help, I'm apt to spank and get it over with quickly, so we can be friends and be happy again!

"If they're quarreling, I'll first talk to them about what's happening. Those who are responsible for the trouble continuing usually get assigned a major job. A big pile of dirty dishes—from nine people at the supper table—can change the atmosphere pretty fast.

"If they're dawdling and making the job take far too long, I'll set the timer. They know they have to be finished by the time it rings. I give them plenty of time—say 30 minutes. They finish in 10, all pleased with themselves!"

Her standard and goal are clear. "We want them to practice the Golden Rule, and honesty and clean language. We are teaching them to obey cheerfully, instantly, and until the job is done."

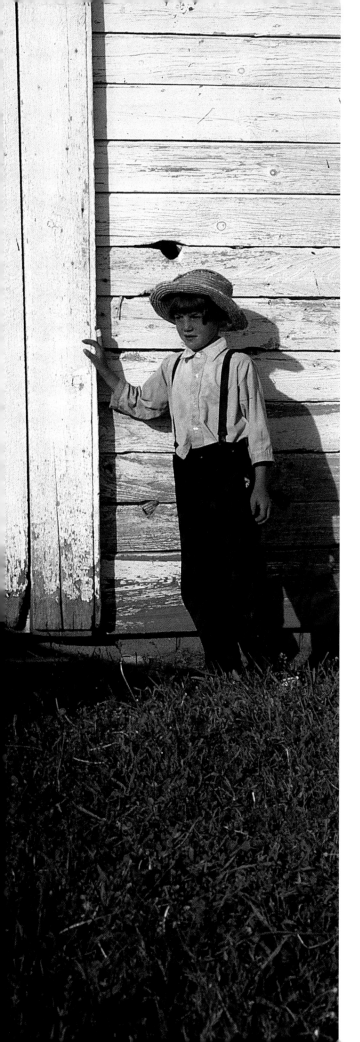

A Three-Generation Effort

One grandfather, who has observed that not all Amish children are as disciplined as they ought to be, wonders if his generation didn't meet their responsibility. "Have we grandparents maybe slipped in what we taught our children?" But he believes that a harsh reaction "to a child who is permitted to do as he wants at home" is not proper. Instead, he says, "It is a gift to talk gently to children and make them want to obey."

This elderly Amish man points to a solution residing within the Amish community—the homesteads that accommodate a three-generation family. "Grandparents and grandchildren can get close enough to bridge some of the differences children feel with their parents."

Parents who may become too zealous about teaching their children "the straight and narrow," as a young Amish mother describes her responsibility, have seasoned wisdom close at hand. A grandmother, now on the retired side of direct childrearing, is still watchful and interested: "Don't make more rules than you want to enforce. The child has to learn what 'No' means. Start with a few things at a time,

Children and animals share a farm's out-of-doors.

43

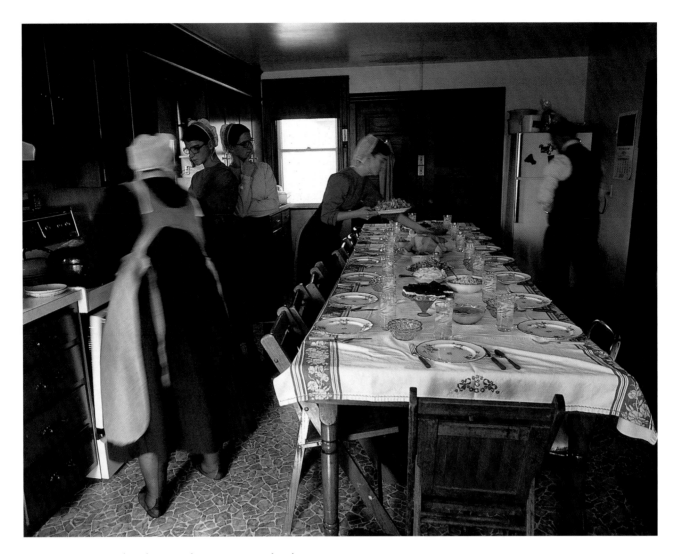

Serving an abundant meal to guests is a family project.

always providing enough sunshine and love along with it. Don't expect your child to be perfect. Grown-ups aren't perfect either."

Helping children grow to be trustworthy, to do their part responsibly, to be humble yet healthy, is a full-time undertaking. The parents who lead their children into these gentle but all-pervasive expectations are those who do it by example, who live within the community, fully a part, never aiming to stand out.

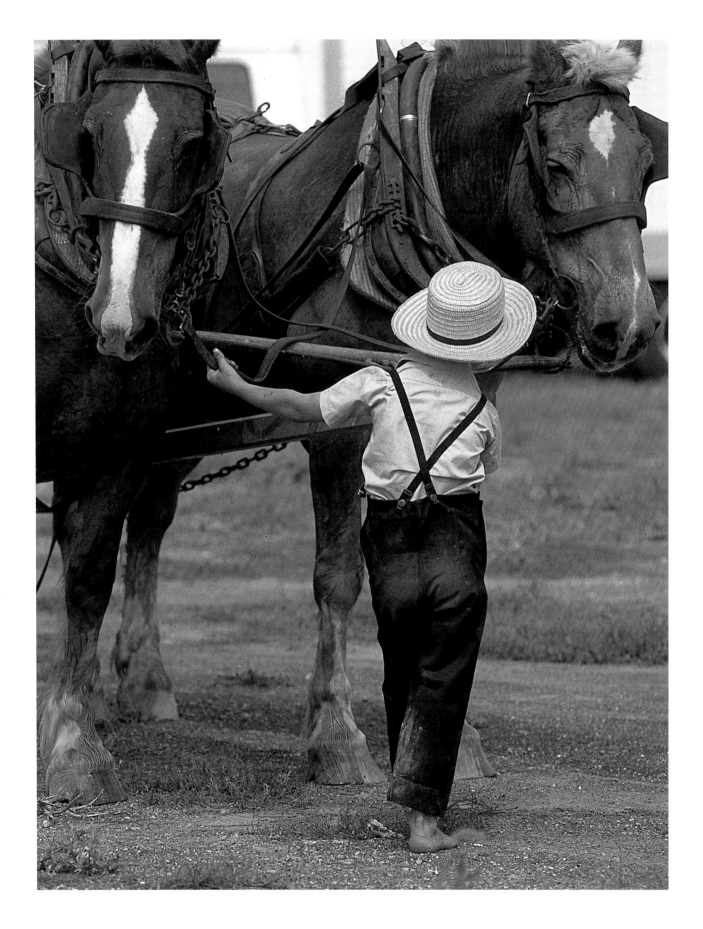

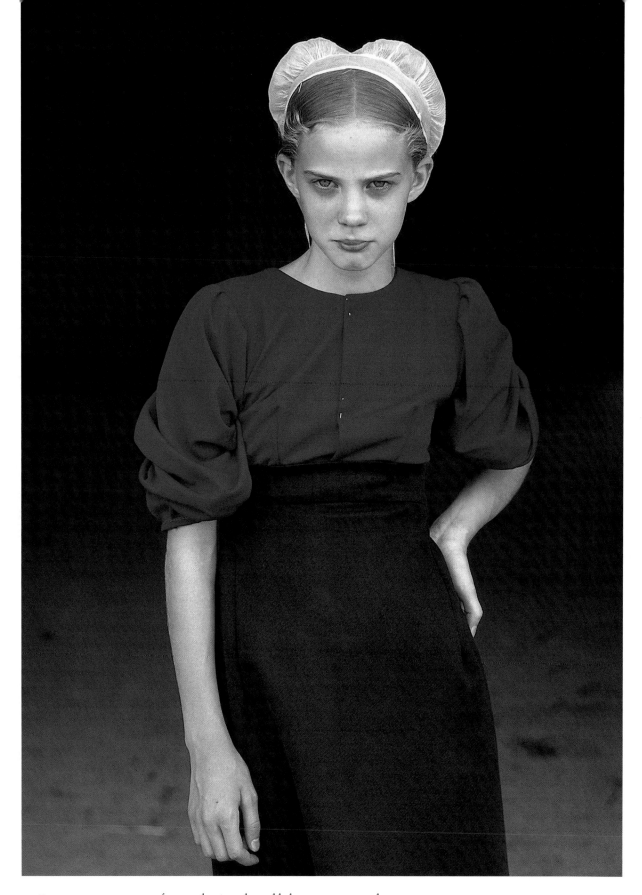

It is more important to fit into the Amish world than it is to stand out.

46

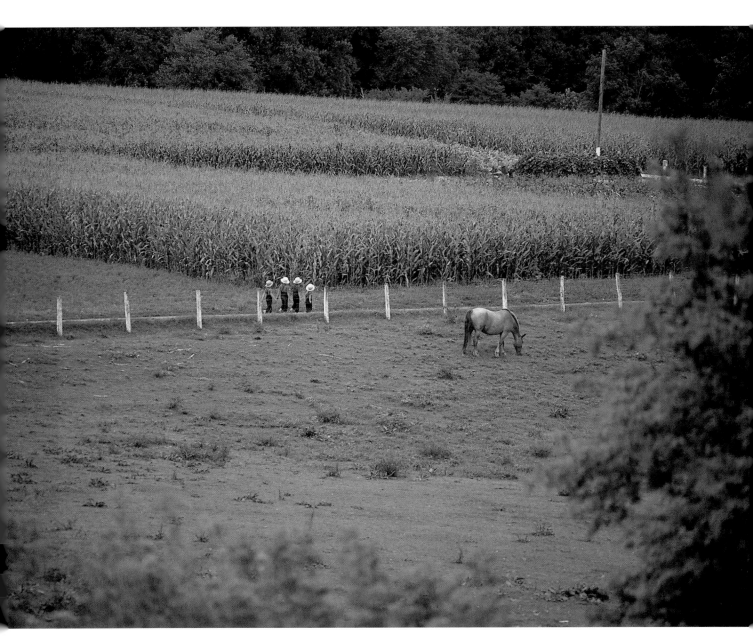

Community thrives, even for children, in these pastoral places.

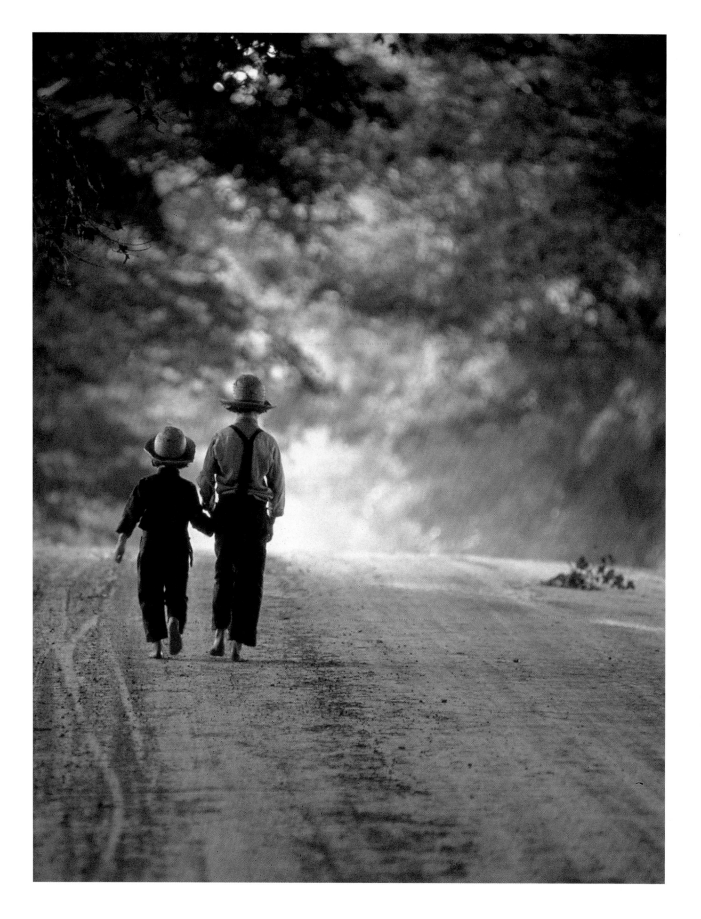

48

GOING TO SCHOOL

When Naomi Stoltzfus and Melvin King head out their farm lanes for their first day of school, their parents know they are simply moving into other Amish hands. Many of the other "scholars" (the Amish term for "students") in their school attend the same church district; all live within the neighborhood. Parents know the three school board members who oversee their Amish-owned school; if they don't know the teacher personally, they are probably acquainted with her family or her church district.

The oldest child in her family, Naomi

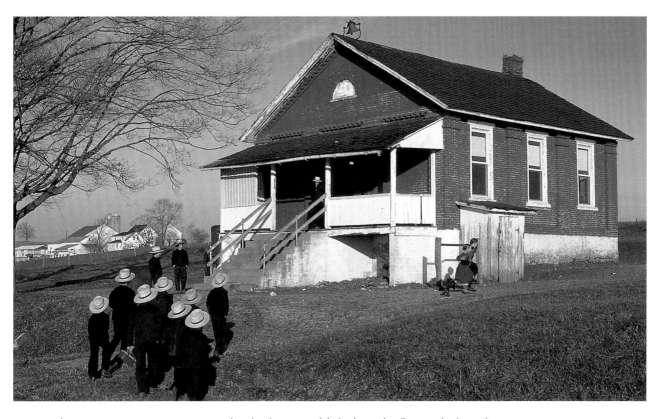

(Above): Many contemporary Amish schools are modeled after schoolhouses built in the 1890s.
(Left): Brothers and friends.

49

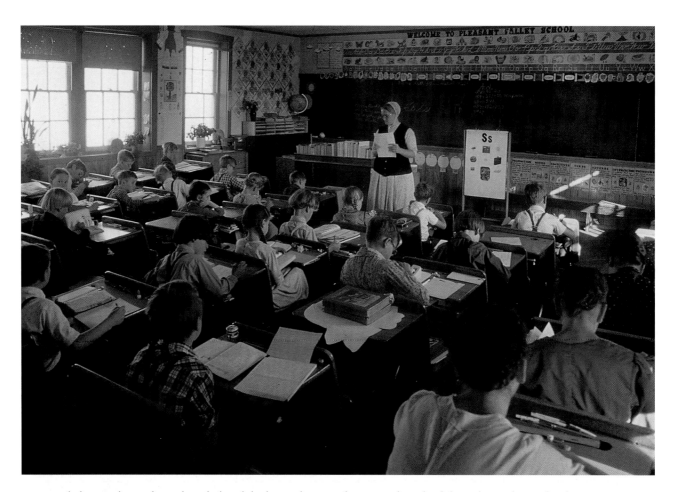

Scholars work quietly at their desks while the teacher spends time with each of the eight grades in the classroom.

knows very little English. Her parents, and *Dawdi* and *Mommy* (Pennsylvania Dutch for "Grandfather" and "Grandmother") who live in the newly built piece attached to her farmhouse, always talk Dutch at home. *Mamm* walks with her to the end of their long lane. They wait together until a group of other schoolchildren come down the road. Naomi joins them to walk the rest of the distance to the one-room schoolhouse.

Melvin is child number six in the King family. He's learned English from his sis-

ters and brothers, and he has company the whole way to school. His brother Ben is cntcring third grade, sister Sarah is going into fifth, and brother David will be in seventh. They shepherd Melvin along, slowing their pace so he doesn't get left behind.

What Makes a School Amish?

Entering school is a landmark Amish children have in common with all other children. Amish parents, by contrast, may be more relaxed than other parents; their

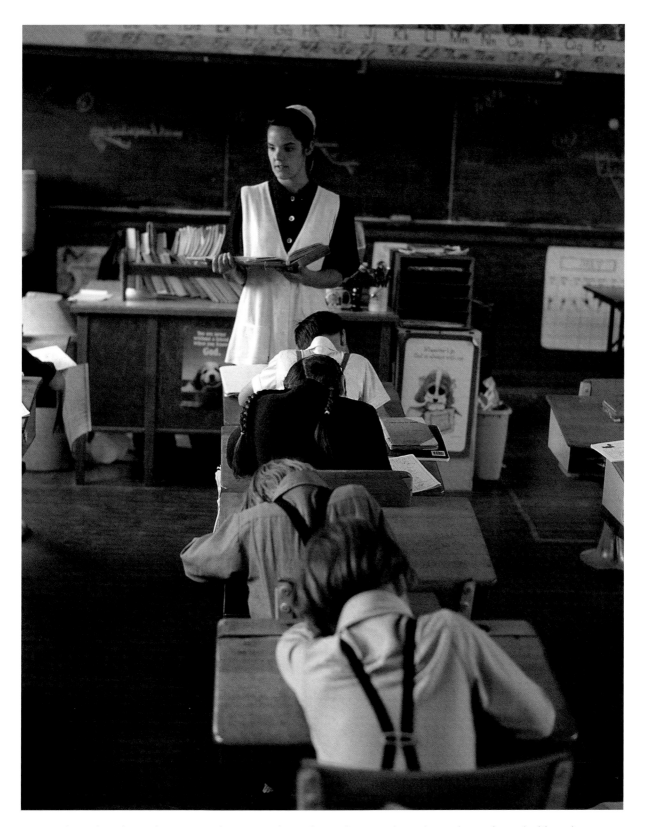

Amish teachers learn classroom techniques and tips from other Amish teachers—by reading Blackboard Bulletin *and by attending six "teachers' classes" throughout the school year.*

youngsters are moving into a known world, designed to reinforce the very ideals and practices they teach at home. Furthermore, these parents likely helped to paint the schoolhouse or mow its lawn; they will probably host the teacher in their home at least once during the school year. The Amish school is a nearly seamless extension of the Amish home.

Amish schools are charged with teaching facts, but they are equally expected to encourage and underscore the attitudes and behavior deemed so essential to the Amish community. The emphasis here is not on earning the highest scores and rising to the top as a distinguished achiever.

Scholars receive grades as an evaluation of their schoolwork, and they certainly anticipate spelling bees, but they are prodded more toward being cooperative and helping others, than toward earning A's or topping out the spelling contest.

Students who struggle with schoolwork are understood to have abilities elsewhere. The Amish believe that one works with what one has been given by God, and a community needs persons with differing strengths. That approach is not

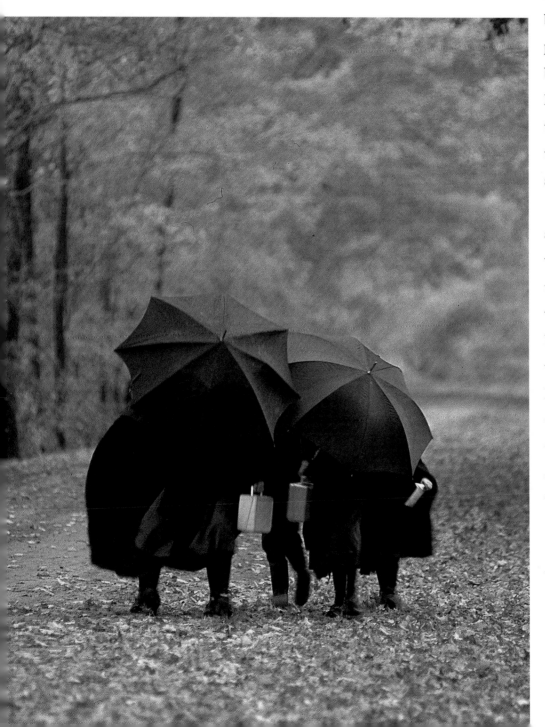

Amish children routinely walk to school.

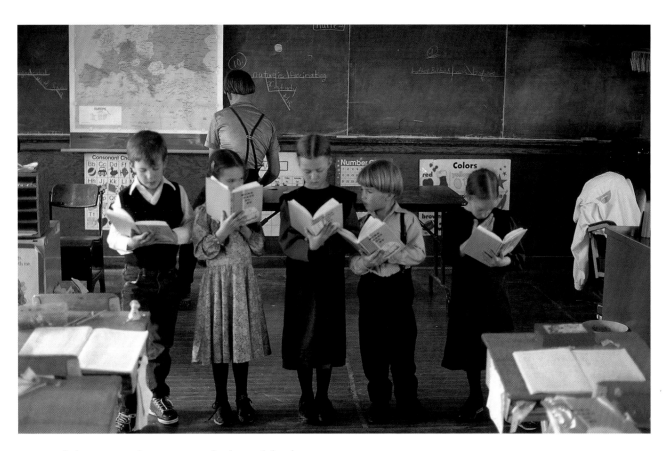

Scholars are taught to recite at the front of the classroom.

Daydreaming

One morning bright my hands relaxed,
 And I was lost in thought.
Instead of doing diagrams
 And what my teacher taught,
I dreamed of an adventurous lad
 Who sailed on many a sea,
And, like Columbus, found new lands.
 Like him I longed to be.

And then I went a-traveling
 To Florida 'way down south.
(I climbed a couple orange trees then.)
 From there 'round to the mouth

Of the Mississippi, long and wide,
 Whose rushing waters flow
Down past Louisiana to
 The Gulf of Mexico.

"Why aren't you working?" Teacher asked.
 I jumped and turned bright red!
"At recess you will write a page
 Of where you've been," he said.
Mists of the Mississippi
 Quickly faded from my view,
While I grabbed my pen and set about
 The work I was to do.

— **By a 6th grade class, Ontario**
(Blackboard Bulletin)

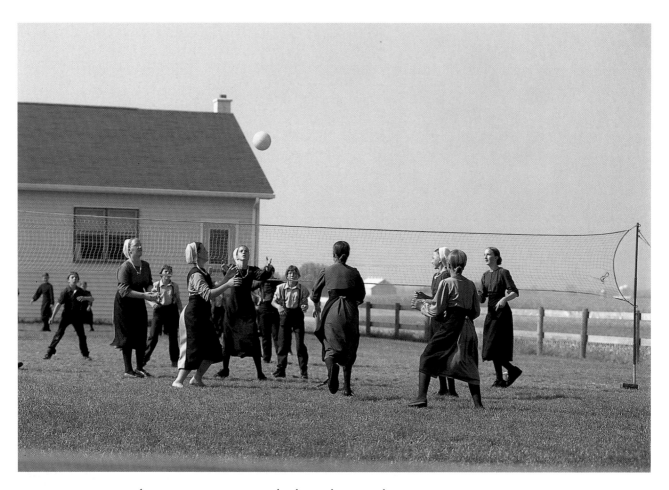

Recess is a time for active exercise. Frequently, the teacher joins the game.

to imply that laziness or negligence will be tolerated! But humility must always be learned alongside facts. Absorbing lots of information does not necessarily result in wisdom nor lead to greater regard for fellow church members.

"Achieving" in an Amish School

One needs a certain amount of knowledge and information to manage a farm or run a small business. Yet the accumulation of facts, divorced from the skills needed to respect other human beings and to be a fully contributing member of a community, is pointless in the Amish view.

"We teach the Six R's in our schools," smiles an Amish father. "Reading, Writing, 'Rithmetic, Respect, Religion, and Responsibility. But first is the Golden Rule."

Curriculum materials come from a variety of sources, including Old Order Amish and Old Order Mennonite publishers. "Today we use a variety of workbook/text-

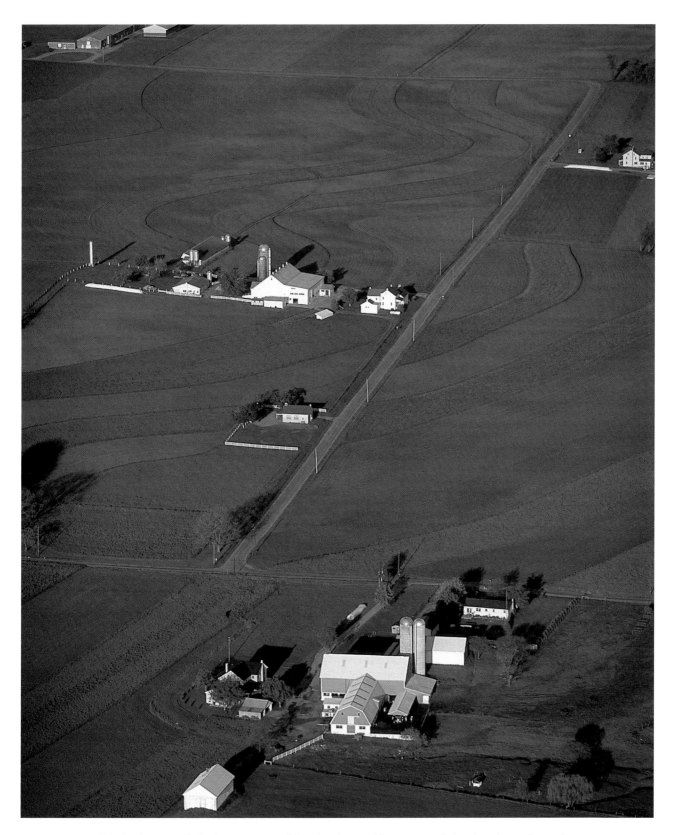

An Amish school is usually built on a piece of farmland owned by an Amish family. The goal is to locate it rather centrally to accommodate the children of the neighborhood who will walk to school.

55

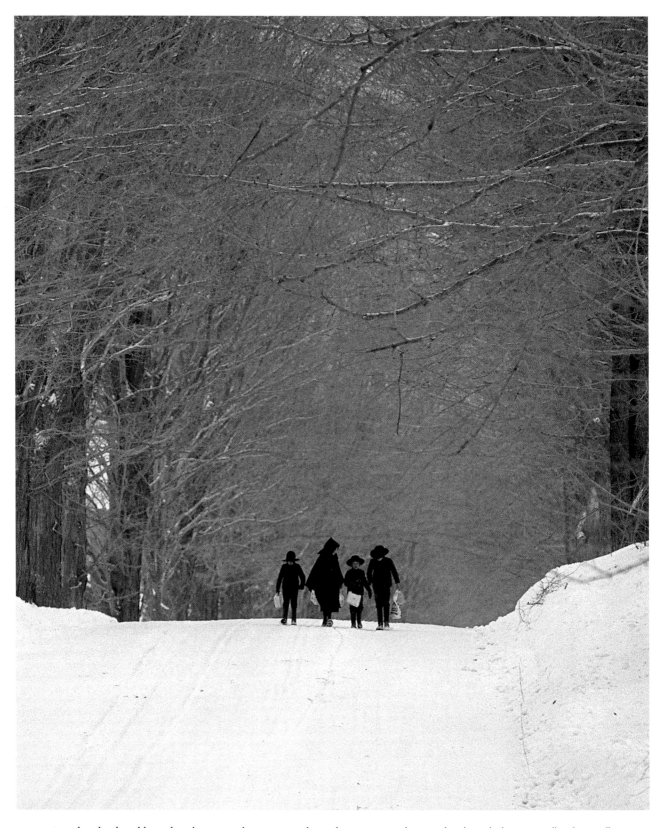

Amish schools seldom close because of snowy weather. If it's too treacherous for the scholars to walk, they will likely travel by sleigh.

book combinations that are easy to work with. They're tailored to a 180-day school year so the teachers don't have to select the material to cover," explains an Amish leader.

Tilting toward the old-fashioned preference for memorization, Amish schools drill the students in multiplication and division tables, in spelling aloud in chorus fashion, in learning poetry and Bible verses by heart. Children often say their lessons together, bringing everyone along in the effort.

Religion is not taught as a separate subject but pervades the whole classroom. Teachers stop short of exposition of biblical texts; that task belongs to the ministers. But children may be assigned to memorize Psalms and the Beatitudes. The teacher may open the school day by reading a Bible story.

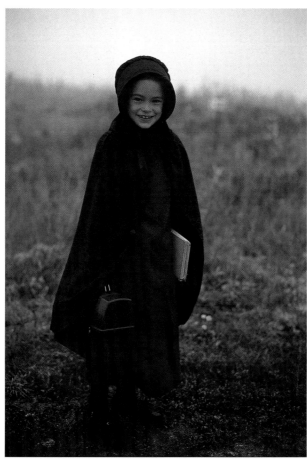

She is prepared for the weather (the Amish do not have school buses) and for lunch (Amish schools do not have cafeterias).

Biblical principles of kindness, concern for others, and honesty thread their way through every activity, including how the children treat each other and the teacher.

An Amish child sits in a classroom with an average of 27 other pupils. Eight grades share one classroom and one teacher. "We copied the 1890 American one-room school system," explains an Amish historian. "The schoolroom layout itself, a six-foot front porch, eight grades together, a six-hour-long school day, a 180-day school year. No gym classes were needed in 1890! And look at all that was invented during those years, without people having lots of formal schooling! Thanks to our American government, we feel reasonably secure."

The Amish paid a substantial price for the privilege of having their own schools,

57

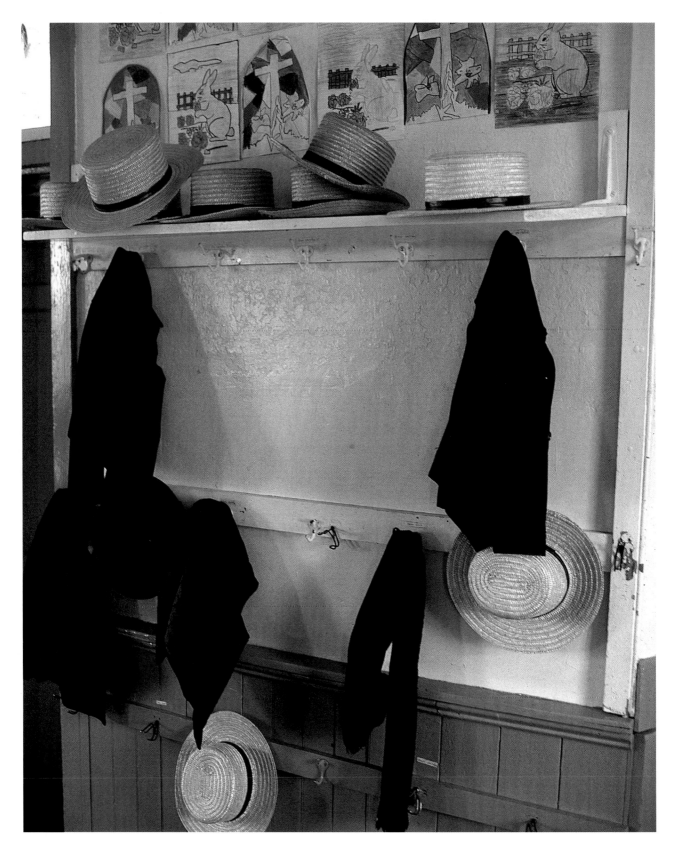

The cloakroom. Every boy knows his own hat.

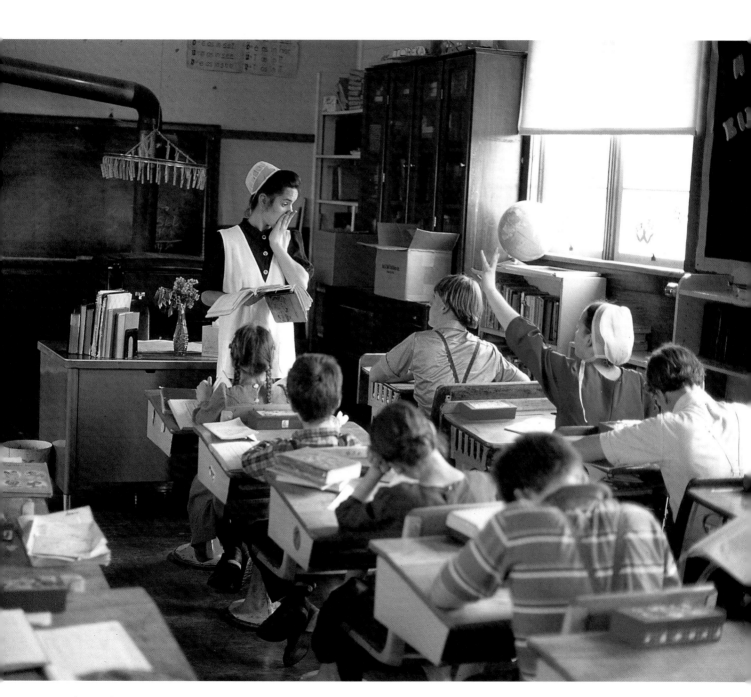

The teacher is a person of authority, but there is room for fun and informality in an Amish classroom.

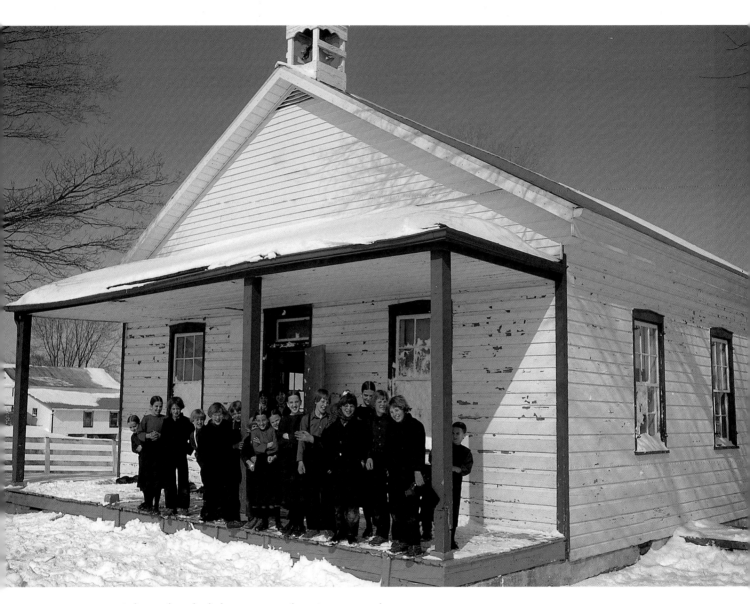

Eight grades of scholars. One teacher. An interested community.

60

run as they wish them to be. Their current set-up is the result of negotiation with the government; the fact of their existence is the outcome of a protracted legal battle which ended with a Supreme Court decision—in favor of the Amish—in 1972.

Teacher Preparation

Young Amish women, typically between the ages of 18 and 20, are "called" by the school board to serve. Under the best circumstances, a young woman is selected who has interest in learning, communicates effectively, has integrity of character, and is devoted to the church. She will have no college education; her training will come from six to eight "teachers' classes" scheduled throughout the school year and a "summer teachers' class." These sessions are conducted by older, more expert teachers, who encourage the less experienced attendees to ask any questions they have. In their time together they may cover discipline difficulties, helping

timid scholars, managing their time, and sharing resources for the Christmas program. Many teachers also subscribe to *Blackboard Bulletin,* an Amish publication for teachers, featuring articles and stories about classroom activities and issues.

Equipping children for Amish life and godliness, rather than preparing students for professional or successful business careers, shapes an Amish schoolteacher's every act. Her mentors, her school board, and her parental constituency link arms around her as she lives out her task.

"Our children look forward to school every fall," says one mother who sends four to the school set off in a field, one-quarter mile down the road from where they live. "And then they look forward to it being over in the spring."

Special Events

In between, the scholars prepare a Christmas program which all their parents and preschool siblings will attend,

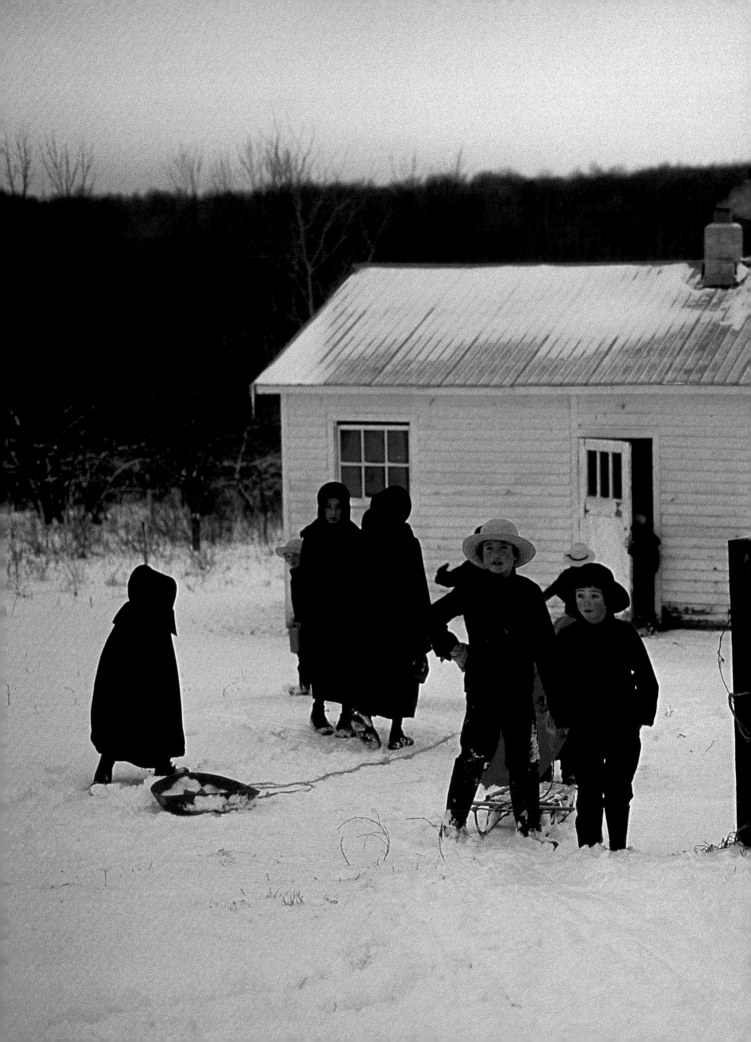

squeezed into the single classroom. The pupils will likely go Christmas caroling, often packed into a long wagon set on sleigh runners and pulled by a sleighbell-bedecked team of horses, courtesy of one of the fathers.

They will probably plan a surprise birthday celebration for their teacher, perhaps under the guise of an all-school supper at one of the family's homes.

The year-end school picnic often includes another program of recitations, music, and (in some schools) skits, and frequently a softball game played between the scholars and their dads.

The children help to decorate their classroom with simple art projects designed for the walls and windows. At times they go singing at the home of an ill or elderly church member, often delivering a scrapbook made of pages created by the students. They may go on short excursions to a nearby woods or stream or visit a neighboring school.

Homework is not burdensome. In fact, states one mother flatly, "There's no excuse for a lot of homework, except for memorizing poetry or Bible verses. They

An Amish school in wintertime Ontario, kept warm by a teacher-tended stove.

63

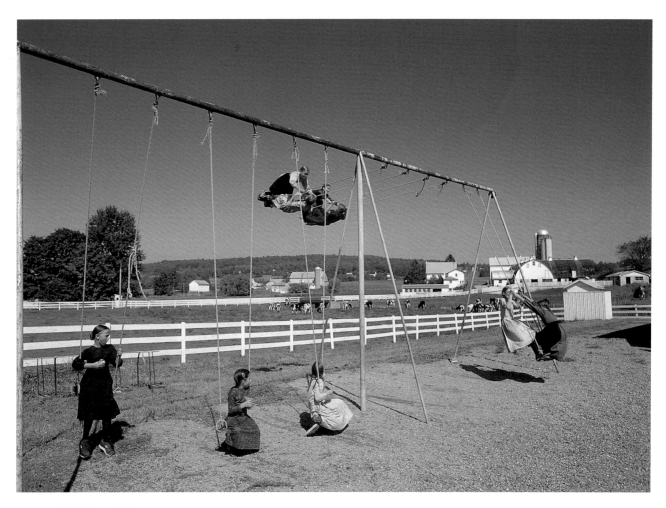

Old-fashioned fun at recess.

can do their lessons while the teacher works with the other classes." Children continue their house and barn duties while going to school. Many feed calves or chickens before breakfast or wash dishes after the family's first hot meal of the day. After school they are needed again, keeping these youngsters occupied and well exercised.

"Extra-Curriculars"

Many Amish families' schedules have no room for sports events (although some young Amish men who have finished school are forming ball teams that play throughout the week). Nor do the youngsters need gym class for exercise. Nearly all Amish scholars walk a significant distance to and from school, put in active time around home—

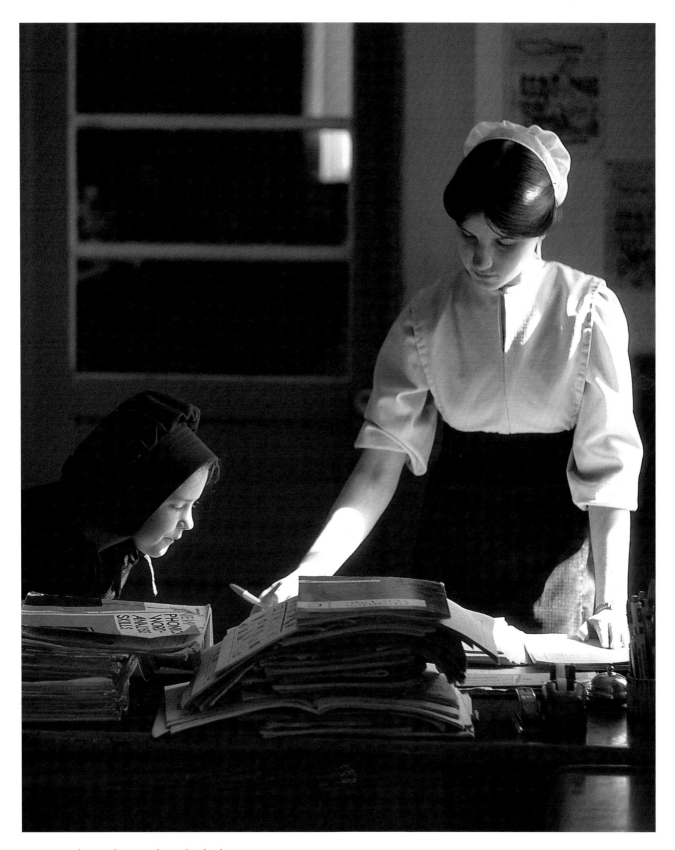

Teachers take time for individual questions.

65

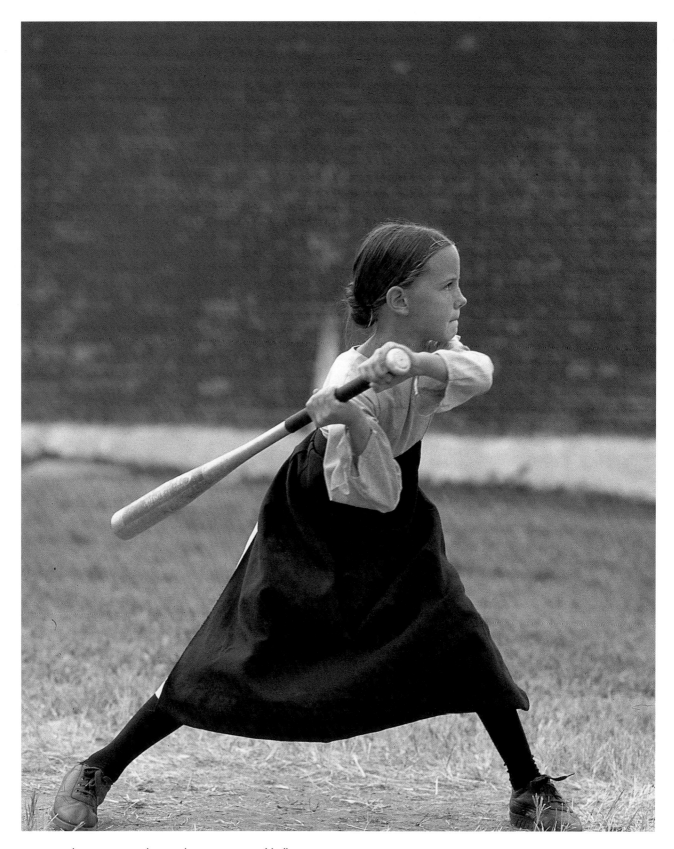

Girls are not just bystanders in recess softball games.

66

and play boisterously at recess, usually in group games aimed at including everyone. Softball and sledding rank as favorites when the weather cooperates.

Amish schools have no cafeterias. But they usually do have a wood or coal stove which not only heats the room, but offers its warm top for heating lunches of soups and leftovers.

Some students have discovered that potatoes bake well if laid in on top of the coals.

Certain more extensive cooking projects are possible in an Amish school, despite the absence of electricity and running water. A school-

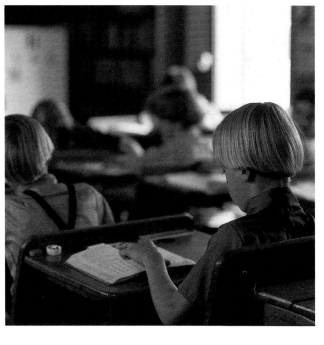

teacher recalls, "One Friday we made home-made ice cream. On Monday we realized that someone had forgotten to take the left-over milk home. I have never seen such sour milk! We decided to save it and make my grandma's crumb cake. The scholars were sure anything that bad would kill us. But after the cake was baked, even the boys copied down the recipe. It was the best coffee cake I ever made!"

Beginning Again

When an Amish school gets too full, a new school is built. Lines on a map indicating which families send their children where are redrawn to balance the attendance between the two schools, keeping in mind the distances children will need to walk.

Families are never split up in these re-configurations. That assures children's sense of security. It also allows parents to attend only one Christmas program and one year-end picnic rather than multiple ones. The practice becomes one more way in which children are reminded where they belong. That, after all, is one of an Amish school's most primary responsibilities.

My Peanut Crop

I thought peanuts would be fun to grow, so on May 22 when the ground felt warm, I cultivated a small spot in the big garden and planted a small row of peanuts. The ground felt soft as I covered the seeds and firmly packed it down.

Soon tiny sprouts appeared and five plants started to grow. I watched them closely and kept the weeds away so they could grow better. It seemed like a miracle that yellow flowers appeared on top of the plants while at the same time peanuts were forming below the ground.

God supplied us with plenty of rain and sunshine this summer. One time we had hail which made holes in the plants. But thankfully it didn't do them any harm.

The peanuts had to stay in the ground a long time. Finally Dad said they were ready to dig. One plant had 45 peanuts weighing one-half pound.

We put them on newspaper to dry out. Then next winter when we have popcorn we'll put them into the popper and that will be delicious!

— LaVern Miller, age 11, LaGrange, IN
[Blackboard Bulletin]

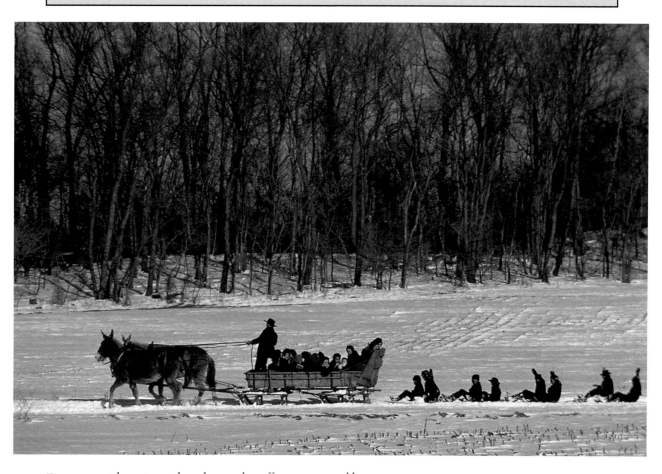

Parents provide outings when the weather offers an irresistible opportunity.

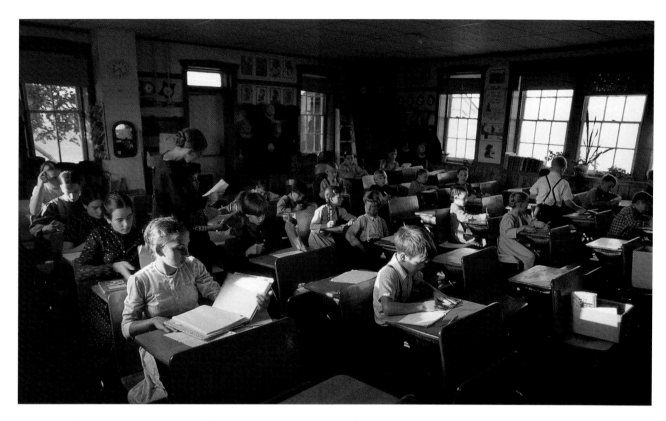

Students and their teacher collaborate to give the simple building a warm and pleasing atmosphere.

Some Facts

Some Amish settlements became acutely uneasy about sending their children to public schools as those schools began to consolidate (from the 1920s to the 1940s) and lost their immediately local flavor. Many Amish also objected when states began requiring that students complete 12 grades. The impersonal nature of the new schools, the teaching of many subjects which the Amish consider irrelevant for their lives (foreign languages, advanced math and sciences, home ec, industrial arts, and gym, for example), and keeping young people in classrooms when they could be learning far more applicable skills at home, especially after eighth grade—all were reasons that the Amish undertook the development of their own schools.

Having those schools become legally recognized was a long and tortured effort, taken up in many individual states where the Amish live. In the end, the Amish were granted the right to proceed, providing their schools met particular state requirements.

One compromise struck in Pennsylvania in the 1950s continues today. After successfully completing eighth grade, Amish children must attend vocational school until they reach age 15. That class meets three hours a week in an Amish school or home. An Amish teacher covers "English, mathematics, health, and social studies, supplemented by home projects in agriculture and home-making."

In addition to attending class, the 14-year-olds must keep a journal of the work they've done throughout the week, reporting what they've learned.

Vocational school is taken seriously. Teachers keep attendance and issue report cards, which include comments about behavior.

In the year 2000 there are 1,162 Amish schools. (The first Amish school was established in 1925 in Delaware.) The vast majority of Amish children attend Amish schools. In several of the larger Amish settlements (Holmes County, Ohio; LaGrange County, Indiana; and Arthur, Illnois) some Amish families send their children to public schools, but they are in the minority.

In most Amish communities, parents are not permitted to homeschool their children. Leaders, acting on behalf of the community, believe the practice could lead to too much individualism. Amish schools are carefully monitored by their school boards, their parents, and, in the Lancaster, Pennsylvania settlement, by the Book Society, five designated men who select curriculum materials and take turns attending "teachers' classes."

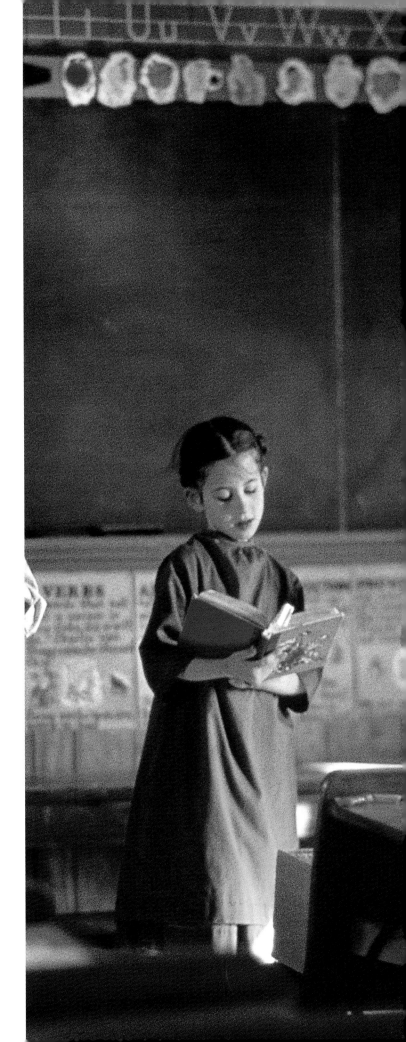

Amish schools do not include kindergarten. Young children have much to learn at home. Parents are more interested in including them in their lives and activities than in accelerating them into a formal school environment.

Amish schools are often said to be made up of 10 or so *families*, rather than of 28 or so *students*. Scholars are often introduced to visitors as belonging to a particular *family*, rather than as being part of a particular *grade*.

Children belong, first and foremost, to their families, an understanding that becomes evident even in casual conversation.

Some Amish parents and leaders are concerned that the caliber of Amish-school education not slip. On occasion, school boards become desperate to find teachers and may select those who aren't well prepared to teach—they may not have a good grasp of the subjects, they may be too young, they may not communicate well. Poorly taught students over time can lead to a slide in life-preparedness, even in this community.

Parents and school boards bear responsibility for salvaging such situations, which are often difficult circumstances to face and to correct. In some communities, parents and leaders agree that the situation needs careful watching and attention.

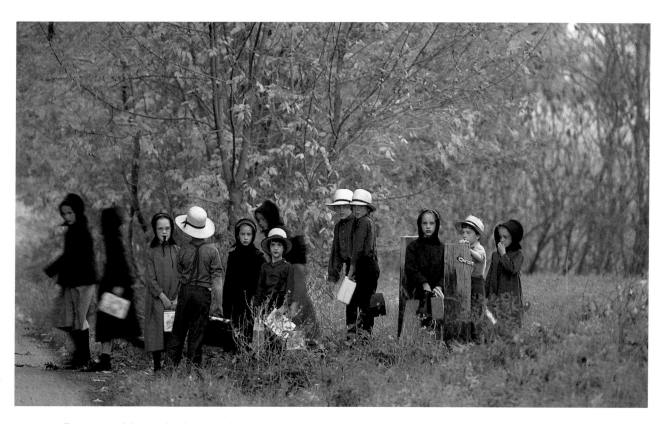

Walking to and from school is an adventure all its own.

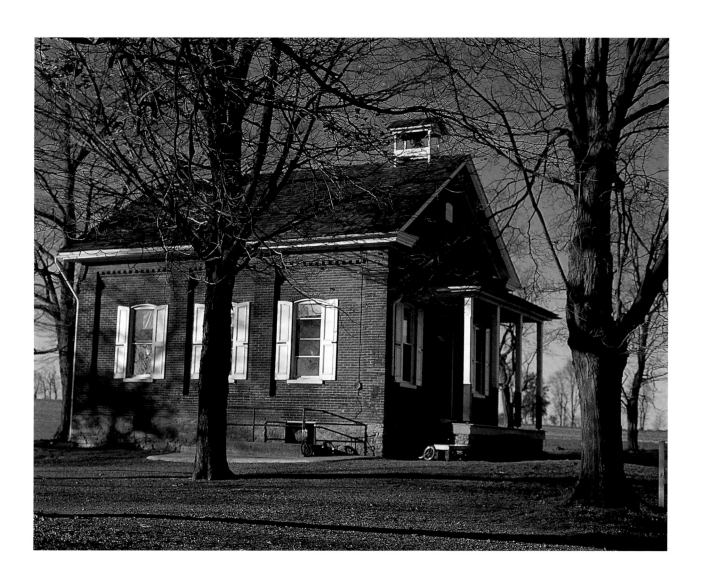

Autumn Days

Autumn days have come to stay,
Dressed in red and gold.
Time to bring the harvest in
For it is getting cold.

The trees are starting to get bare,
The leaves are drifting down,
Geese are flying overhead—
They are southward bound.

We labor in the garden
Which is quite a chore;
The harvest is rewarding
And we need no more.

Thank you, God, for autumn days
When our blessings flow,
For our beautiful harvest—
These, great God, to Thee we owe.

— N.K. *(Blackboard Bulletin)*

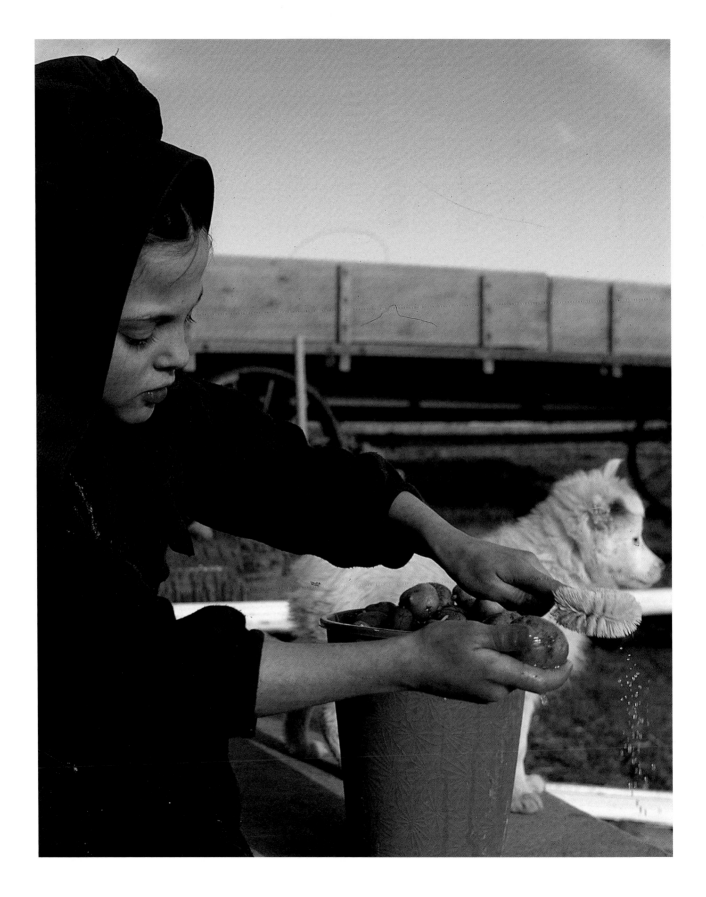

74

LEARNING TO WORK

Learning to work is as high on the agenda for an Amish child as learning to read. Furthermore, an Amish child is educated not only to learn to work, but also to *see* work to do and to *like* to work.

The Amish find satisfaction in work. It is one thing to teach a child particular skills, to instruct in method and procedure. But within the Amish approach, that is the small half of what needs to happen.

Helping Sam and Rebecca to develop an appropriate attitude toward work is as

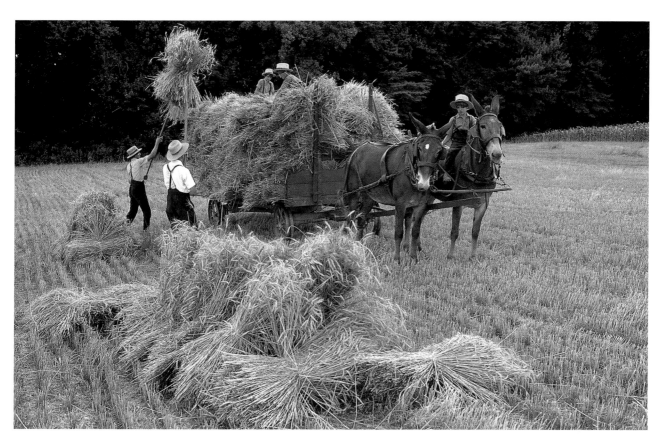

Children join in work projects, with careful tutorship from parents and older family members.

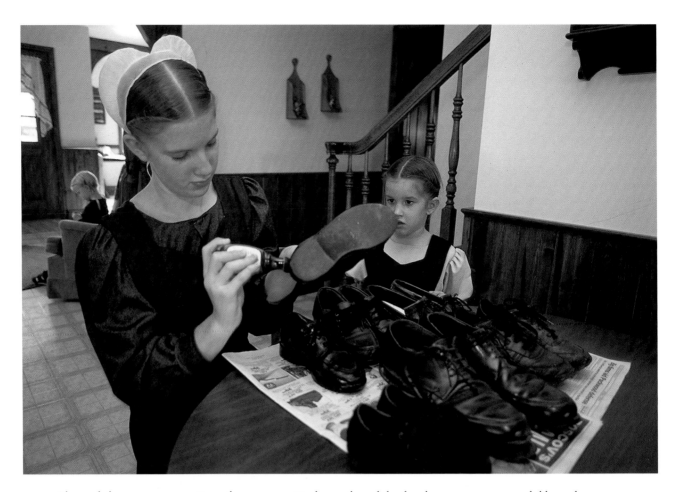

Shoe-polishing is a routine Saturday practice. Each member of the family, averaging seven children plus parents, wants his or her shoes shined for church.

essential, if not more so, than teaching him when to plant corn and her the proper "feel" of kneaded bread dough.

A child can go to school or read instruction manuals and be adequately educated for some tasks. But learning to work, developing respect for it, and finding fulfillment in it are abilities a child absorbs only by spending hours with someone who has already discovered meaning in work.

In this, the Amish start early. "They usually help as soon as they can," states one mother who is rearing seven youngsters with her dairy farmer husband. "If they can't help, they're still on the scene." These parents capitalize on children's interest in mimicking what they see adults doing. They accept the frustration that well-intentioned, but bumbling, little hands can cause. "Let him help," *Mamm* instructed her school-age daughter who was getting tired of her three-

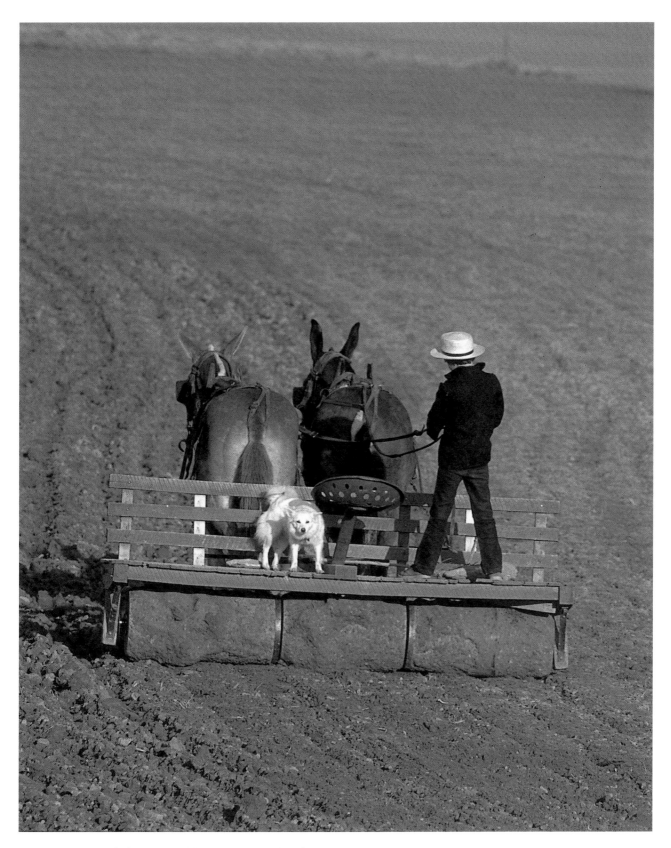

Farming with horses is a labor-intensive undertaking.

year-old brother's efforts at assisting her with folding laundry.

To Work Is to Be Trusted

In this setting, being permitted to work and to help are nearly synonymous with being trusted and being needed. It is not that the work itself is especially pleasurable. Hoeing a cornfield and shelling peas are monotonous and boring jobs. But one child seldom works alone. Mary, Katie, and Ruth are assigned to cleaning the house; Ben, Levi, and Daniel to milking and feeding. *Mamm* and *Datt* are seldom far away, often within shouting distance if not working alongside in the project at hand.

One Amish mother sees daily, routine work as an opportunity for more than getting a job done. "It is very important to be close to our children and to encourage them to confide in us. I have learned that the best way to accomplish this is by confiding in them also. I make a habit of having them with me while I work and tell them what I'm doing and why."

Observes an Amish dad, "Parents have much better success if they say to their children, 'Come, let's do the chores,' rather than,

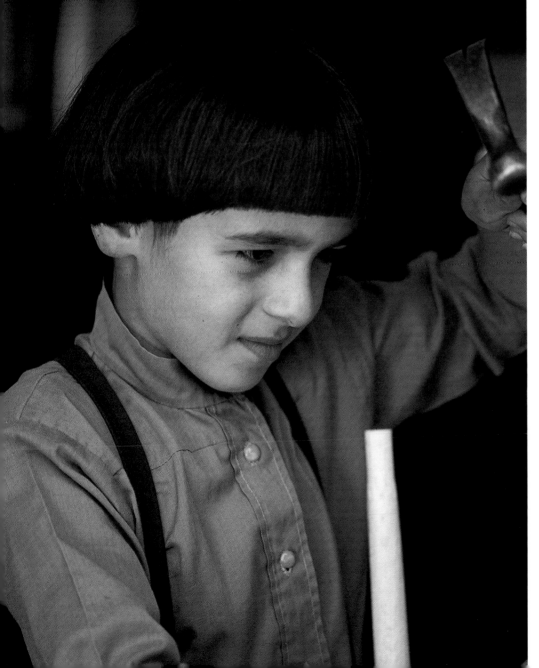

Children learn a multitude of skills at the elbows of their parents and grandparents.

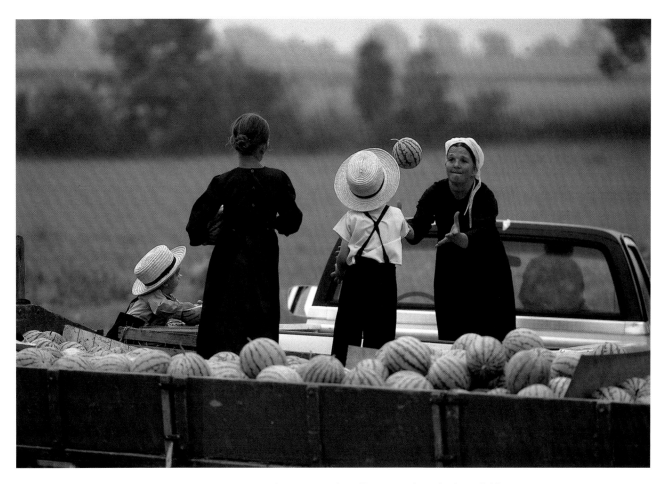

Work can almost be fun. Many parents make a particular effort to work with their children.

Practice Makes Perfect

When our family moved to a farm six years ago, I was fascinated watching the others milking our cows. They did it so rapidly and expertly. In a few evenings I too was begging to try it. I did not realize how complicated it is for someone not used to milking.

The first time I tried to milk a cow, I was given a gentle and easy-milking one. But even then I perspired freely and my arms ached as if they would fall off.

The next time I tried it, it was just a little easier. My arms were still tired, but I hoped with practice, that would improve.

It did improve. Six years later I am still milking cows. This is something I enjoy, especially with the family participating and we can sing hymns together. Also, I have learned, "Practice makes perfect."

— **Rachel Hochstetler, grade seven**
(Blackboard Bulletin)

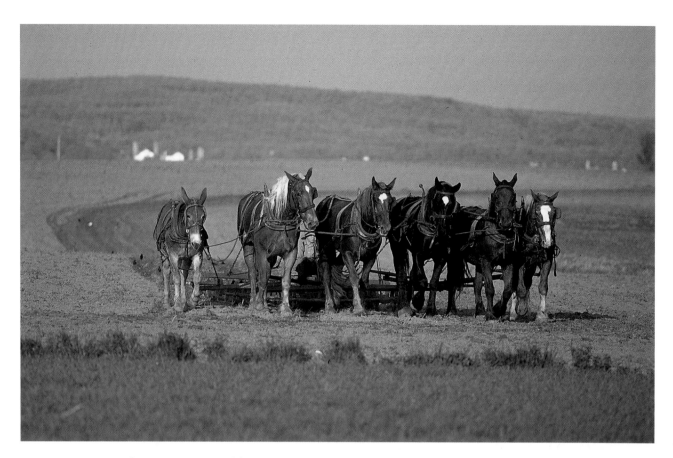

Driving six mules requires responsibility, concentration, and know-how.

'Boys you better go now. It's time for you to chore.'"

One mother of 11 children, despite the size of her family, still advises finding companionship while working together. "Chore lists work well, if the mother helps each one a little. Don't just send children to work—try to work with them as much as possible. Be interested in their work and play."

Dealing with Drudgery

As parents and children work together, respect can develop in both directions. As children's skills improve and their circle of responsibilities widens, their lives take on increased meaning within their family and, over time, within the Amish community. The wisest parents build in valves so their sons and daughters don't come to hate their jobs or feel like slaves. "Time off" is cherished; a long lunch break is a bonus; homemade root beer out on the yard-swing, as crickets and lightning bugs fill the twilight, is a reward and reprieve.

A grandmother speaks from her experience: "Teach them to do chores around the

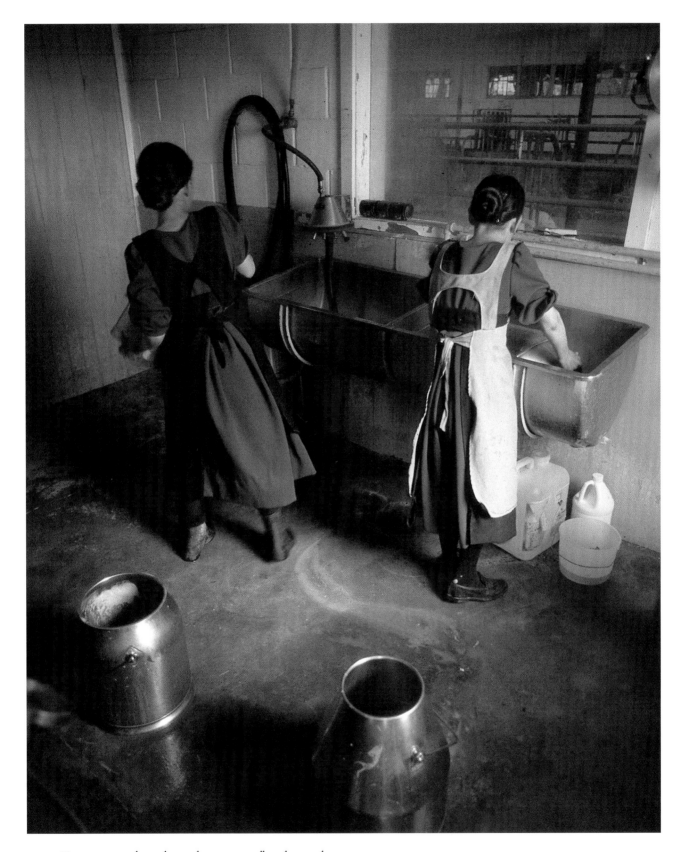

Young women learn barn chores, as well as house duties.

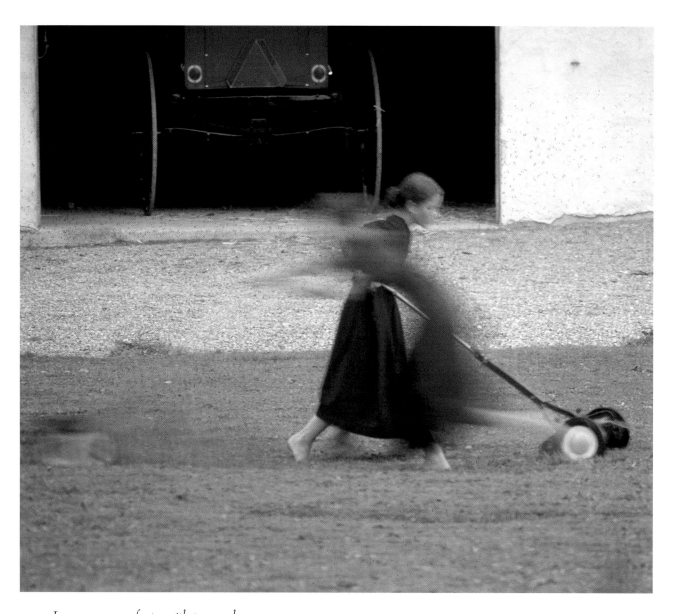

Lawn care goes faster with two push mowers.

82

house as soon as they are old enough to understand. This teaches them responsibility. When they get older, always allow some playtime after they have done their work.

"Do things as a family, working and playing together. This is much better than letting them run to the neighbors all the time. They will be much more content and feel closer to you if you have happy times together."

What are young children asked to do? "Ours help to clear the table of dirty dishes, wash dishes and wipe them, sweep the floor—at least by the time they go to school," offers a mother of seven.

Animals, despite their size and power, can be friendly presences.

True Tasks

Amish girls and boys are not subjected to make-work. "They first help to gather the eggs and feed the chickens, so that by the time they're eight, they're on their own with those jobs," explains a grandfather. "At about that time they'll start working in the fields—or at least taking water out to those who are driving the team."

Horses and mules are as familiar to Amish youngsters as cars are to other children. They learn to handle the animals by observing the older members of their families. "Working around a horse just comes," explains a father. "If the horse is tame, you might start driving in the fields and around the farm at age seven, but not alone. If you're going to hitch up a horse, you have to be tall enough to throw the harness up over the horse!"

Girls may cut fabric patches as soon as they can safely handle a scissors. At an early age they may be given a big needle to make a canvas bag so they develop ease with needlework tools. By age 12, they are doing

Garden helpers.

84

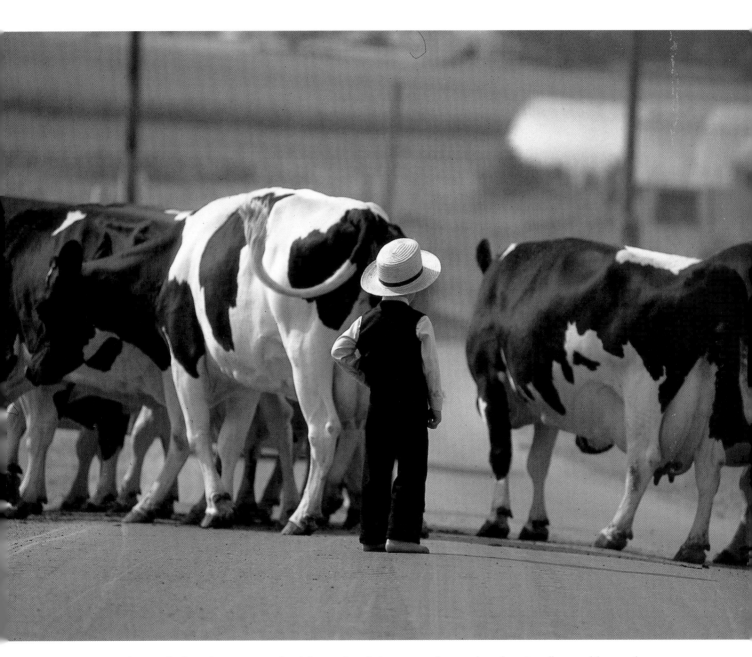

On some farms, the barn lies on one side of the road and the pasture lies on the other. A well-trained boy and well-behaved cows work together to help safe passage happen.

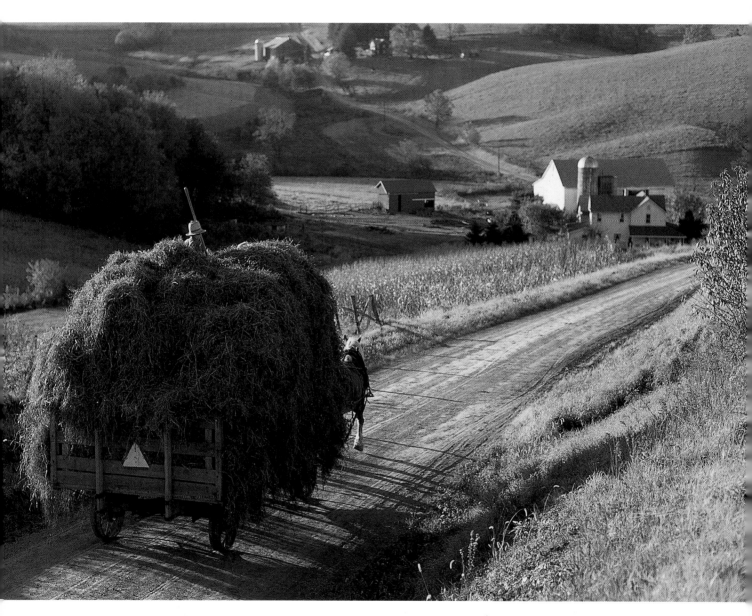

Taking the hay home to the barn from the field.

serious sewing—by hand and on a treadle sewing machine. Soon thereafter they try quiltmaking—piecework, applique, and quilting itself. "They may not all be good at that," acknowledges a young Amish mother, "but they need to know how to do it."

Preparing for Life

All this intensive work instruction is to do more than supply *Datt* and *Mamm* with a well trained crew of helpers. Children are certainly needed to keep a homestead and farm or business functioning, but they are also being prepared for the rigors of running their own households and related operations.

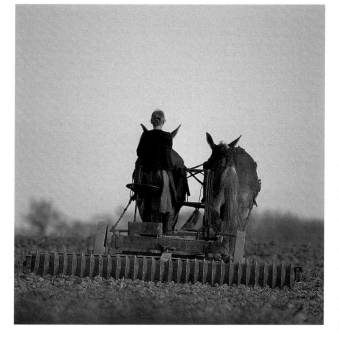

There is no crash course available for learning to sew most of a family of nine's clothing, (two parents, seven children on the average), to raise a garden that will supply the majority of their food, to till and harvest fields with mules, and to produce an adequate family income from one's 40- to 50-acre farm (the average size in the Lancaster, Pennsylvania Amish settlement).

Because the Amish are currently doubling in population every 20 years or so, and there is not adequate farmland available to meet their demand within existing Amish communities, the Amish have begun to turn to other jobs for their livelihoods. Farming is highly labor-intensive. But cabinetmaking and furniture-building and quilting may not require the help of the whole family.

For those reasons, Amish young people in their early to mid-teens increasingly "work away." Girls may take cleaning jobs in the nearby town or city in non-Amish households. They may help young Amish families with lots of little children. "Many of us have help a day a week or so with the laundry, with baking and cleaning, and even some babysitting, so Mom can have a catch-up day or work at the sewing machine," explains a mother.

"Working away indicates that a child has achieved a certain level of maturity," comments a father. "Now it happens a little younger than it used to."

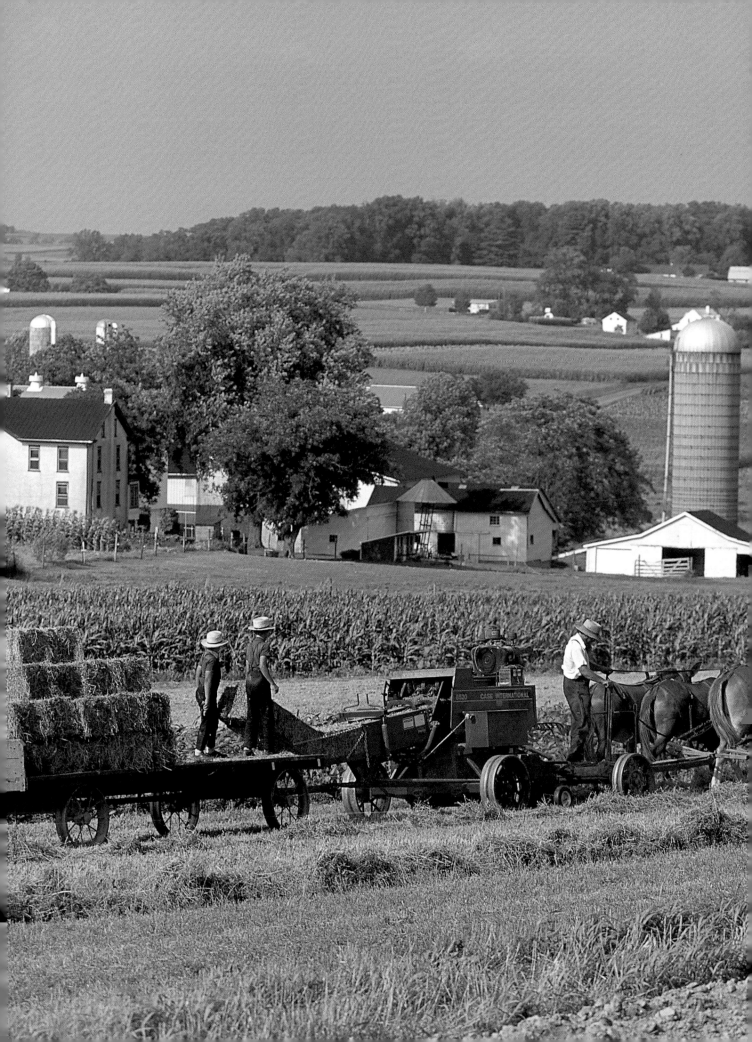

Apart from the sound of diesel engines around the barn or the insistent whine of the wringer washer just off the kitchen, an Amish farm is a relatively quiet place. Many farms are back a lane away from traffic; most noises are natural—primarily animals and children. Conversation can happen gently and easily, without competition from television, radio, or telephone.

Discovering a Proper Attitude

It is an atmosphere for tutorship in particular skills, but also in quality and pacing and ethics. It allows the sort of conversation to take place that an Amish grandfather overheard. "That morning at the breakfast table *Datt* told his boys who were 10- to 14-years-old that there were two jobs that ought to be done that day. The hay should be cut and the corn should be cultivated. 'Which do you think we should do?' he asked them. That kind of question was teaching those boys how to think. They felt respected. A discussion like that takes away the generation gap.

"Children start to get a pleasure out of work. They feel good about their accomplishments without necessarily being

The boys learn not only how to cut and bale the hay, but when it is ready to be harvested.

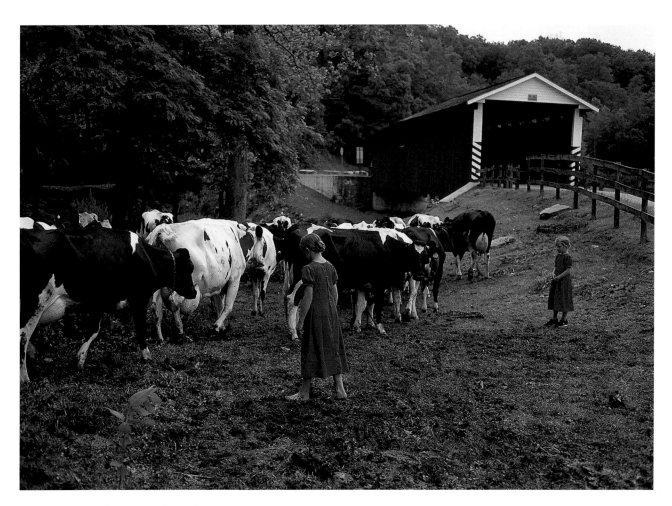

Bringing the cows in for milking.

proud. It begins all the way back when they are school boys and girls. They work hard—and they see things getting done, and that is desirable for them as individuals.

"It's our people's *attitude* toward work that makes it all work," he finishes up.

A discipline of patience pervades Amish work. As the children get acquainted with the seasons and the weather—and their effect on farming and gardening, as they live free of cars and email—and wait for the bus and the postman, they learn a tempo that allows them contact with each other, with the earth, with limits—and with opportunities—they may otherwise miss.

90

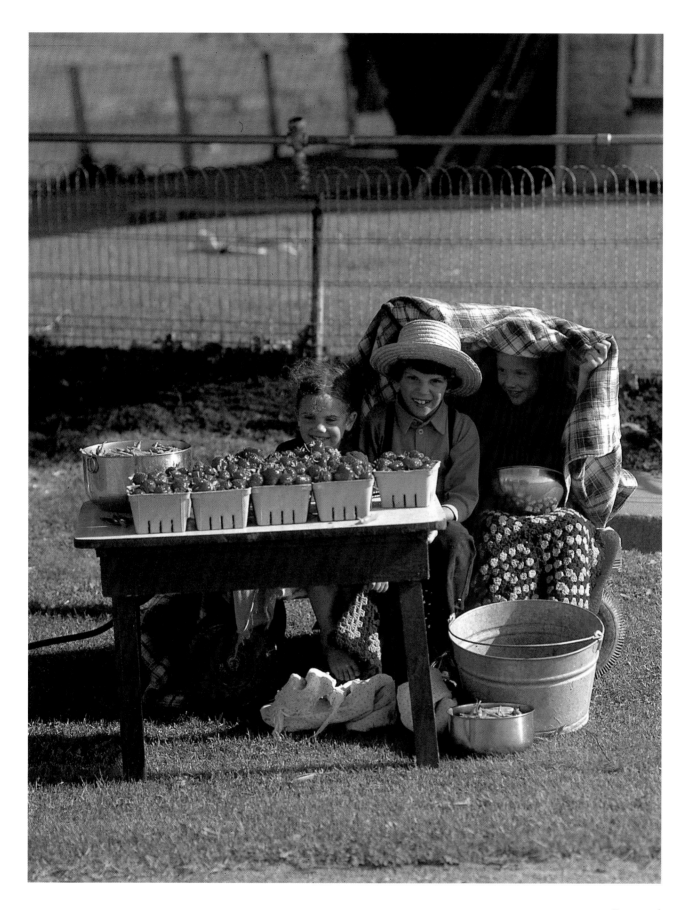

91

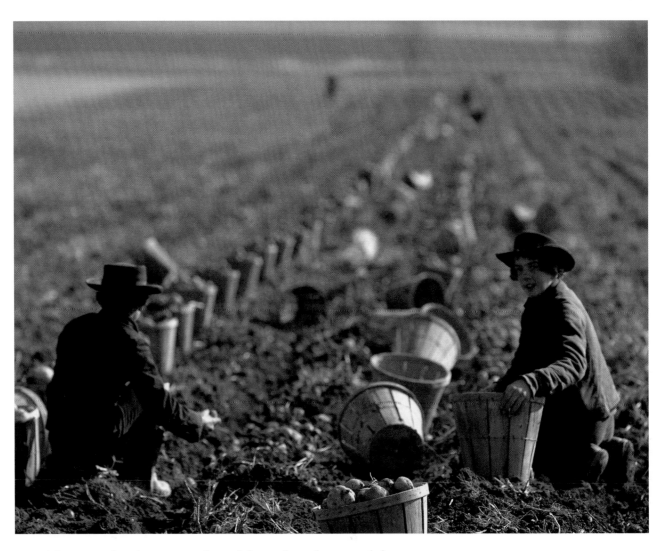

There are miles of potatoes to dig and then pick up, but many helpers.

In a day's time, a lot of feet move through an Amish kitchen, the busiest room in the house.

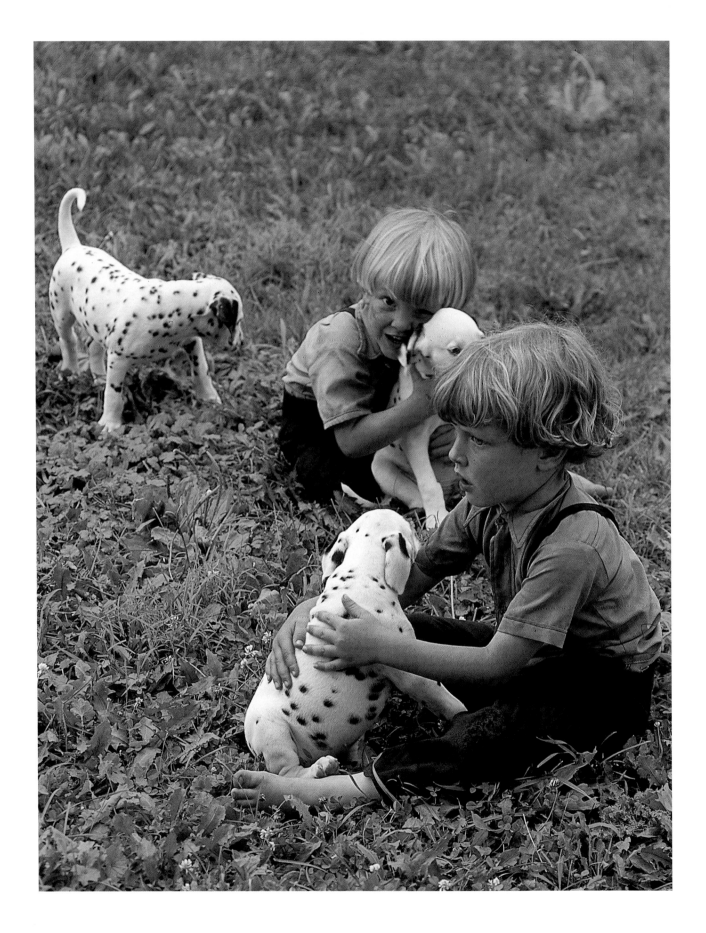

94

HAVING FUN

The Amish work hard, put in long days of labor, dress soberly, look austere, and appear inexpressive, at least in public. While they learn to find pleasure in work, most families also weave diversion and fun into their week.

Entertainment is home-grown and self-generated. Toys are basic and minimal in number: balls, swings, a doll or two, several small trucks and tractors, scooters and wagons. Amish children usually suffer no shortage of playmates, pets, or space. Until they reach third or fourth grade, these youngsters have blocks of time in which to play.

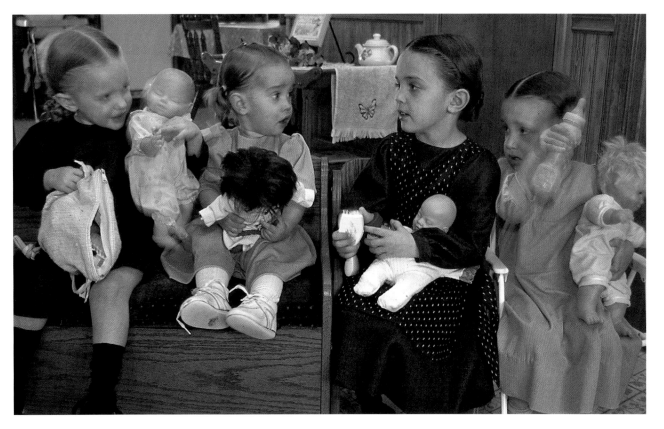

Amish children are rarely without playmates—for endless games of "pretend."

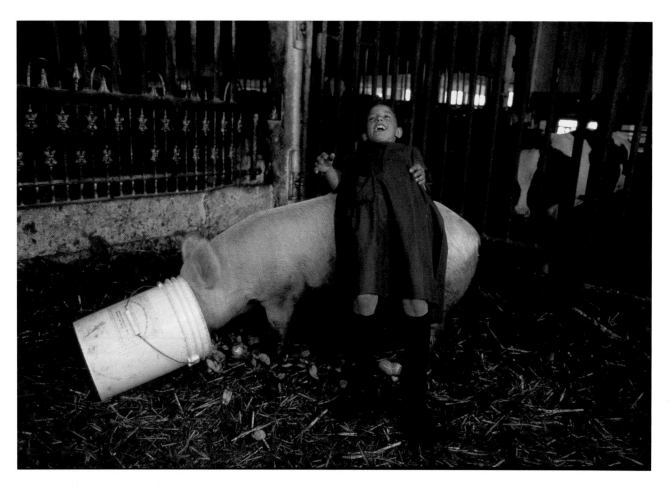

Rowdy animal. Rowdy girl.

They tumble into active, imaginative, pretend play, many times imitating familiar Amish adult activities: "school" and "house" and "horse," "sales stable" and "store" and "market."

In some families, children are encouraged to read, although parents often despair of finding books they believe are appropriate.

From late fall into early spring, many children (often joined by their parents) play table games in the evening after supper. Gathered in the spacious kitchen, around the main light in the house, everyone who's old enough and interested picks up a button or handful of cards. An older sister may make popcorn or stir up cookies—and no one misses the absence of television or computer games.

When field and garden work intensify in mid-summer, there are fewer evenings of relaxation and reverie. The youngest children still gallop around the yard until they're taken into bed, but playtime gets squeezed for anyone old enough to help fin-

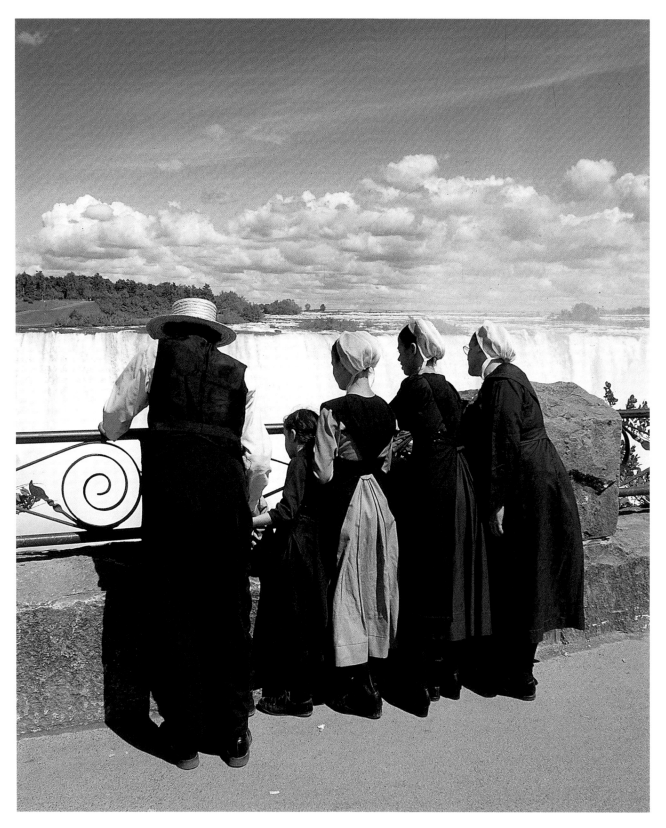

On those unusual occasions when an Amish family takes a pleasure trip, they tend to visit natural wonders, in this case, Niagara Falls.

97

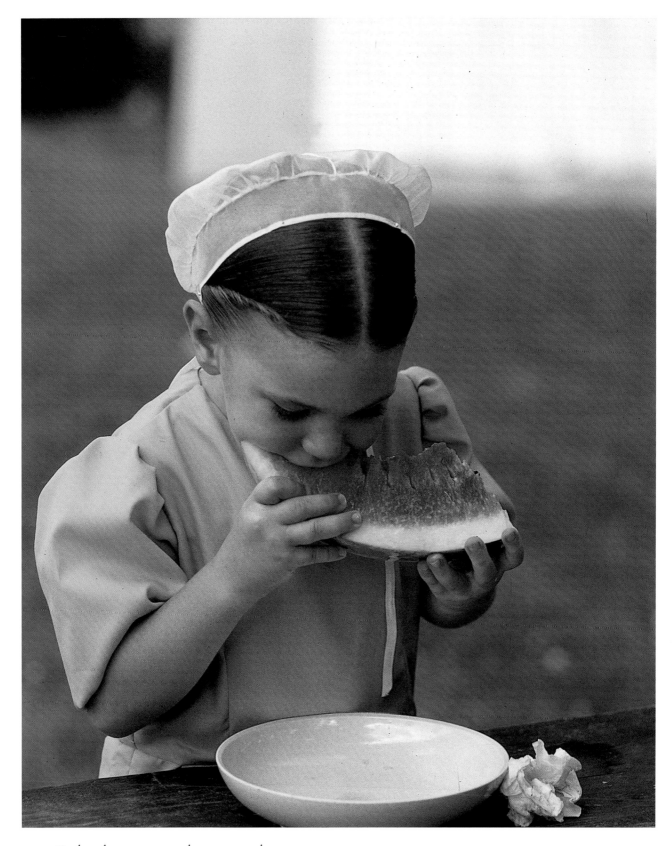

Food is pleasure; watermelon is a special treat.

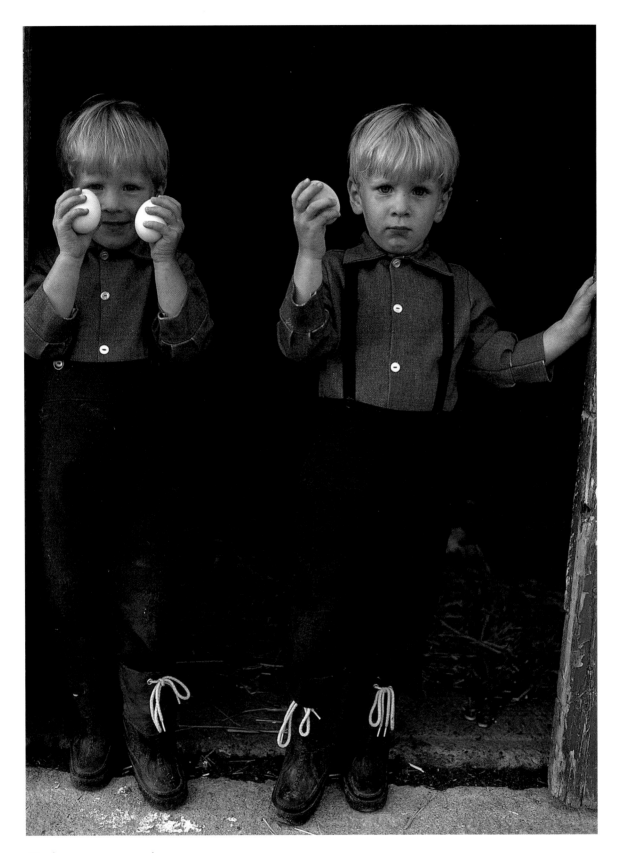

Two boys, two eggs, and, it appears, secrets.

ish trimming the lawn or sweeping the barn hill. Now and then the boys may have a chance for a quick swim in a nearby creek or pond at the end of a long day of sweaty work.

The Highest Form of Amish Entertainment

It is on Sundays (when work, apart from feeding the animals, milking, and preparing meals, is staunchly prohibited) that every-one looks forward to visiting—the highest form of Amish entertainment. After church and lunch, both held in the home of one of the member families, the youngsters are free to play and the adults to visit. Boys may head to the barn to snake through hay tunnels; girls and boys alike may move from hide-and-seek to games of Prisoners' Base and Fox and Geese.

The older children often take long walks, visiting and telling stories as they go.

Before the afternoon is over, and before the dairy farmers head home to milk, more food is served, always a cherished element in Amish social occasions.

Highlights in a Serious World

Children anticipate their birthdays, which, depending on the family, may or

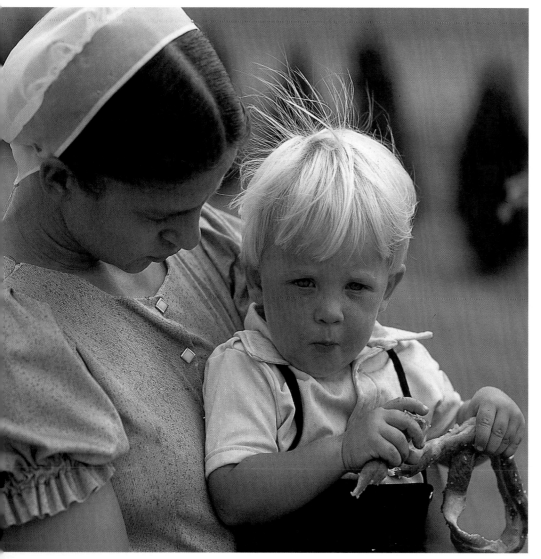

Babies are beloved.

100

may not be marked with a celebration. "We usually have a cake," comments one mother. "Gifts maybe, if there's something they especially need or want at the time. Some of our extended family may drop in, but not as a rule."

"My husband's parents visit all their grandchildren on their birthdays," smiles another mother. "There's always a party, and all the cousins and aunts and uncles can come. A little

gift may go along with it all, but it's mostly the getting together."

One grandfather remembers Christmas similarly. "Christmas stands out to me from my childhood. We didn't get much, but the highlight was being with our cousins and visiting with them."

Children get more gifts these days, says an Amish mother of four under the age of 10: "For

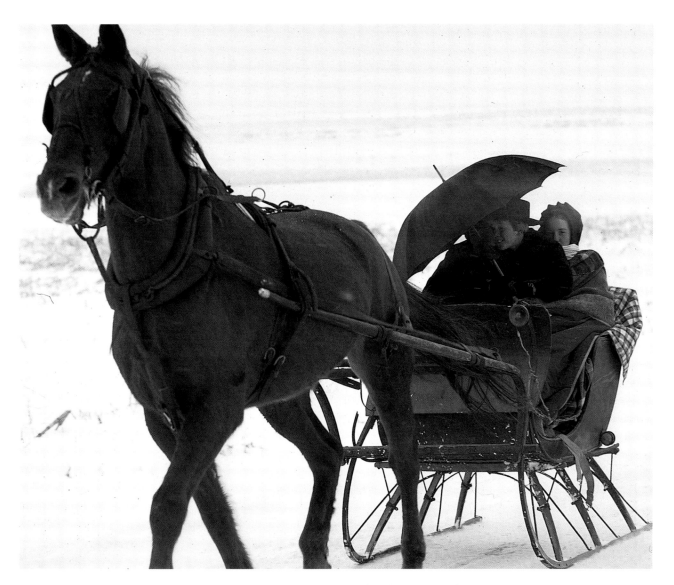

Sleighs materialize from Amish barns when snowstorms blanket the countryside.

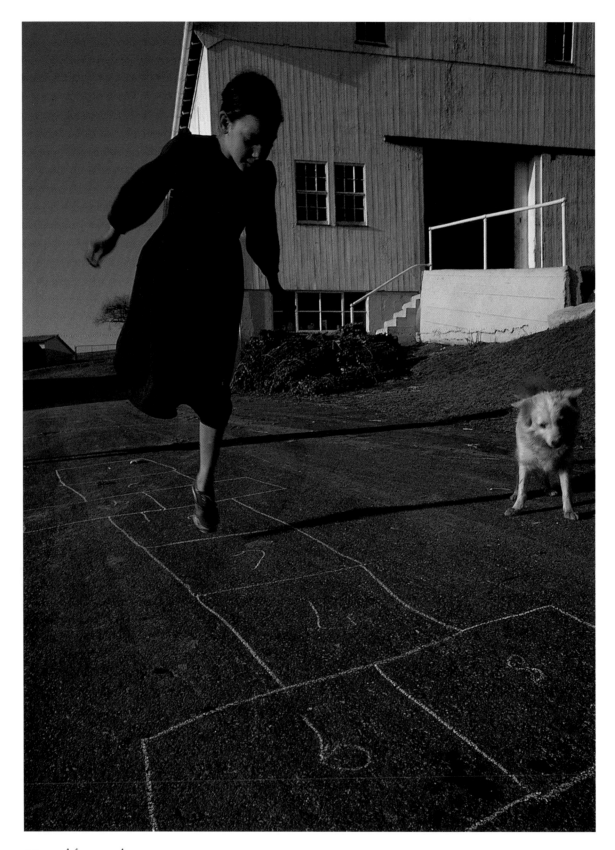

No need for gym classes or sports camps.

102

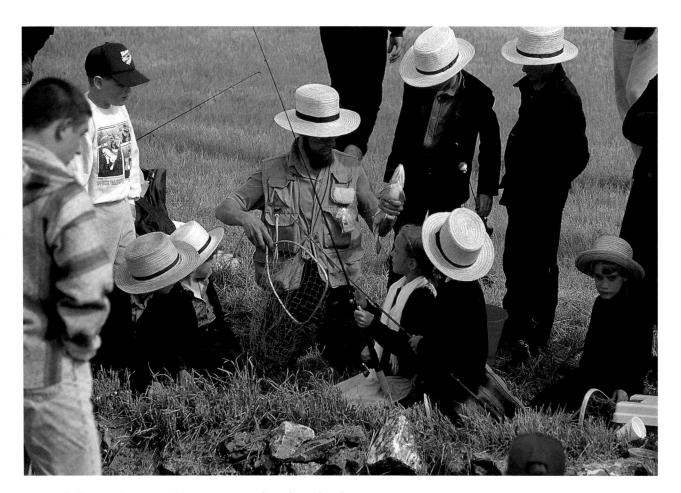

Children and parents alike enjoy natural, and nearby, diversions.

Fishing Fun

Fishing is very much fun for me,
Going to the river, sitting by a tree;
Taking my line and casting it out,
Then reel in a big fat trout;
Take it off and let it go free,
See it go swimming on with glee;
Then go eating and have lots of fun,
Eating a sandwich and a real big bun;

Then go back and catch a big bass,
Throw it back in the water,
 not on the grass;
Then go home, shouting with joy,
I caught two fish
 and I'm a nine-year-old boy.

 — **a third grader, Danny Troyer**
 (Blackboard Bulletin)

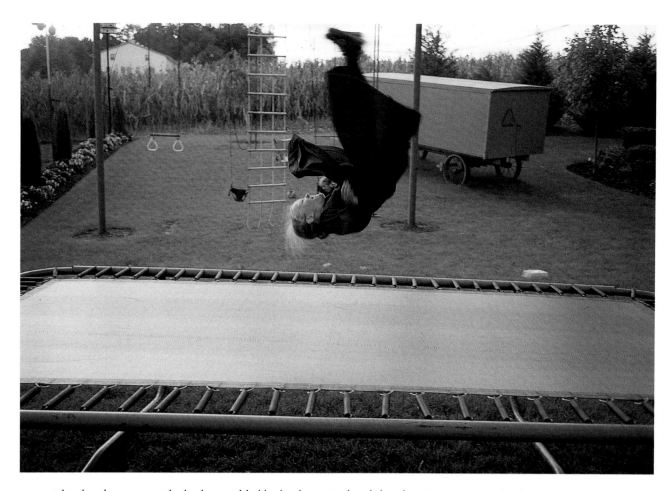

The church wagon in the background holds the district's church benches. Every two weeks the wagon moves to the family who will host church in their home. Despite the flurry of activity surrounding that event, this girl takes a moment's break.

girls—dolls, books, pretty dishes, clothes as they get older. Little boys get trucks and tractors." That, despite the fact that they will not be permitted to drive or own such vehicles after they become members of the church.

Amish families do not take vacations. Work is not seen as something to escape. Besides, it would be impractical for most families to leave their abundantly productive fields and gardens in the summertime.

And who could substitute (apart from an emergency) in the dairy barn—milking, feeding, and giving the care cows require?

Getting Together, Keeping Connections

In some areas, Amish families may make a day-trip to a zoo. Some also go to the beach, wading at the edge of the ocean, fully clothed except for their feet. Family reunions, whether held as a summer picnic

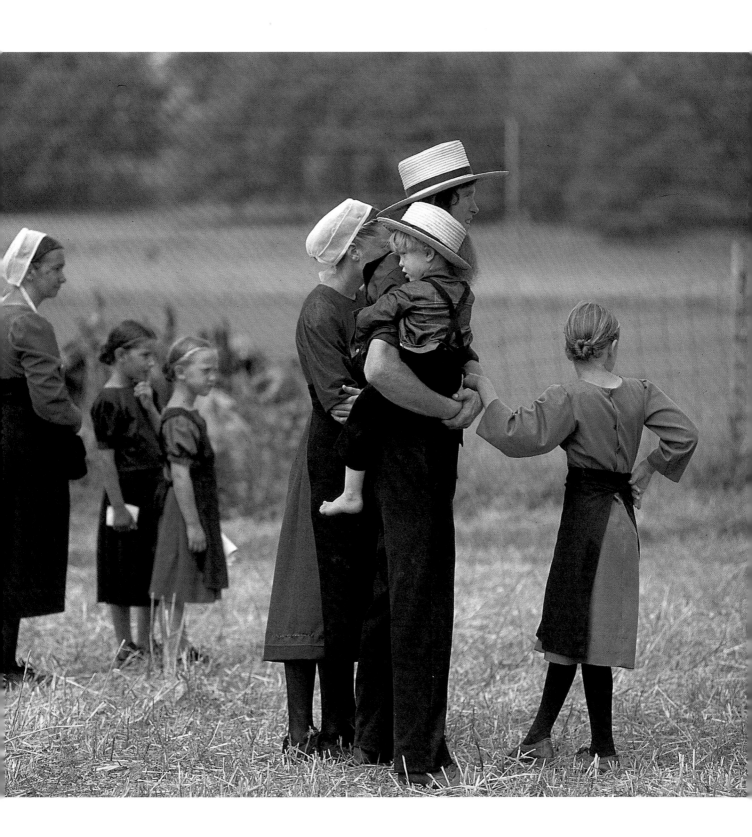

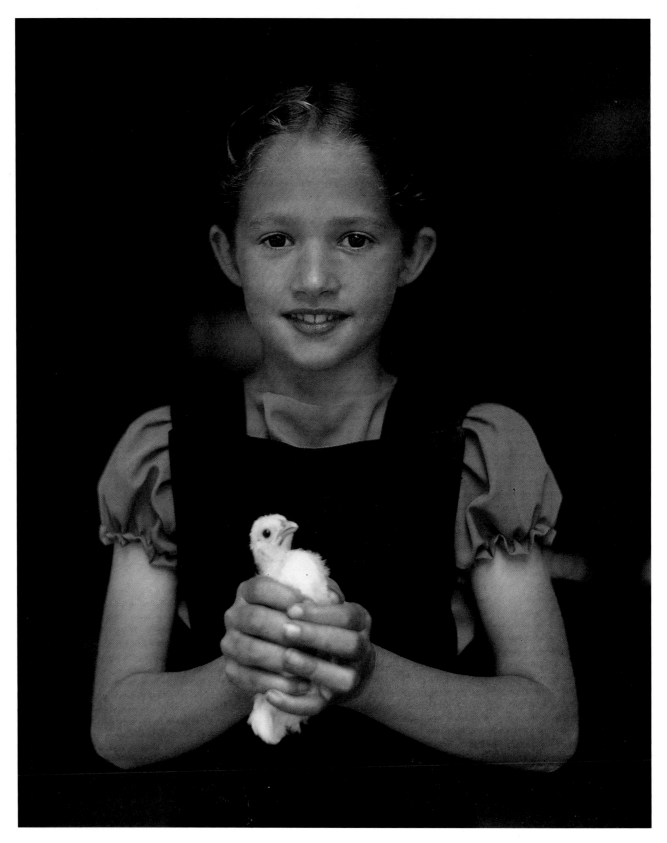

Companionship in a quiet world.

(with mountains of food and visiting and volleyball games) or Christmas dinner (with feasting and stories and memories) are highpoints for all ages.

Most fun times for Amish young-sters and their par-ents are family- or community-cen-tered. From writ-ing letters in the evenings to one's cousins and to friends who may have moved to a new settlement, to ice skating next to a roaring bonfire on a neighboring farm, Amish chil-dren experience fun within their own circles. Horses and bug-gies can't go long distances, and Amish homes do not have phones or email access. Yet the Amish community carefully struc-tures regular social activities to act as a glue and to temper the pressure to work constantly.

A bunch of Amish children and a rope can turn quickly into a morning of playing

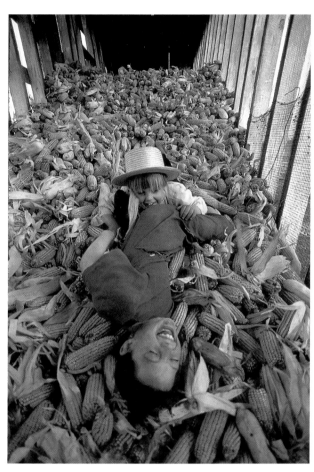

A makeshift slide.

horse; four or more Amish boys and a ball can mark off a cornerball course and lead to a bristling game; a handful of Amish girls can bring out their needlework at a moment's notice and swap patterns and stories while an evening slides by. It may all be play, but it's inte-gral to being and becoming Amish.

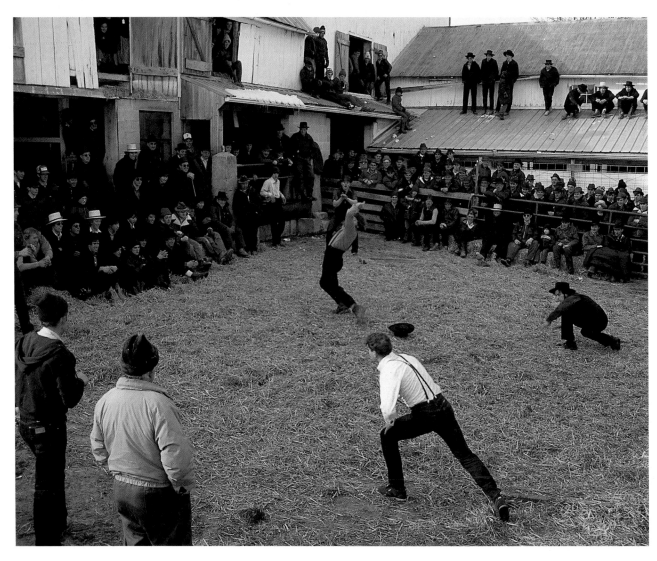

Cornerball. A young men's game involving a ball, speed, deadly aim, swift response, and a sweeping audience.

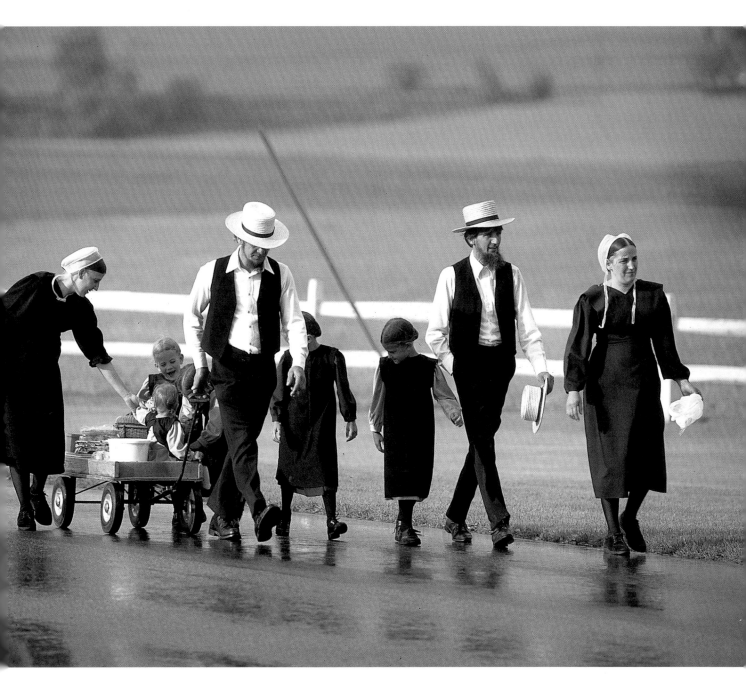

Church is over, as is the rain. Mothers, holding daughters' caps, fathers, and children visit on their walk home.

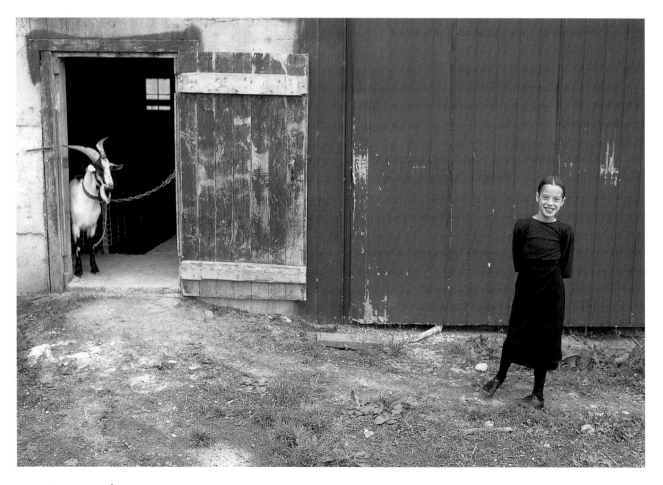

Farm comedy.

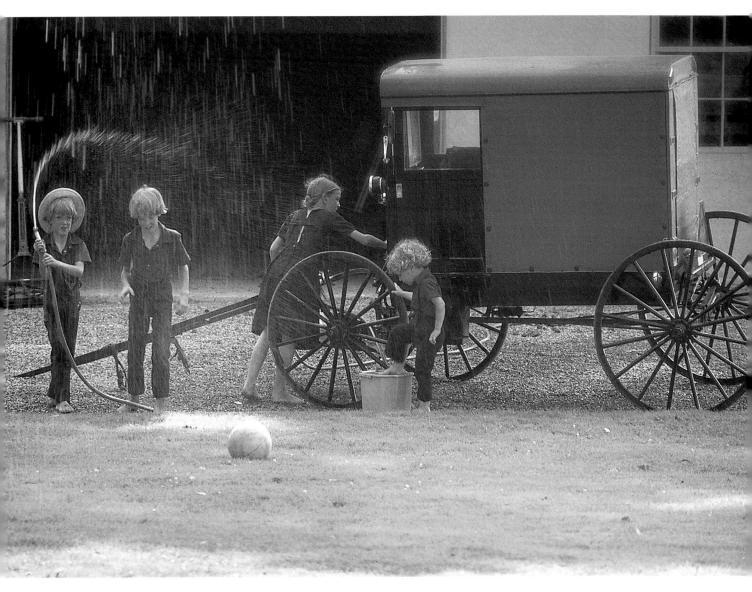

Helpers at the buggy wash.

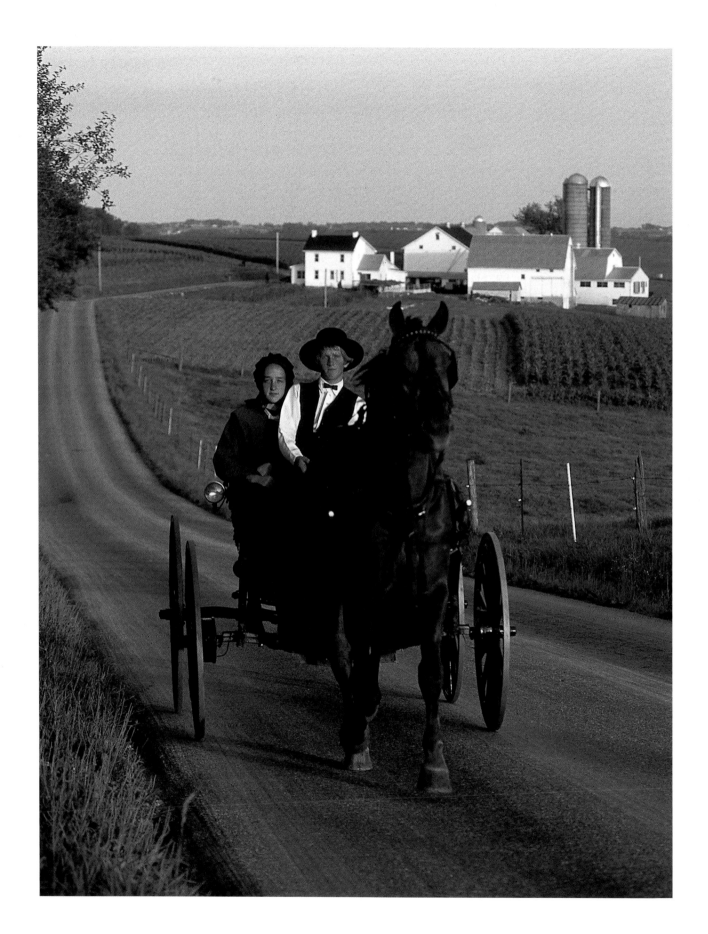

"GOING WITH THE YOUNG PEOPLE"

*T*urning 16 is an event of true significance for Amish young people. The anticipation does not center on beginning to drive legally; most of them first did that at age 11 or 12. Rather, at age 16 they start "to go with the young people."

The act is a clearly marked step toward adulthood, toward the moment that will

(Above): Sunday afternoon recreation.
(Left): Going visiting.

113

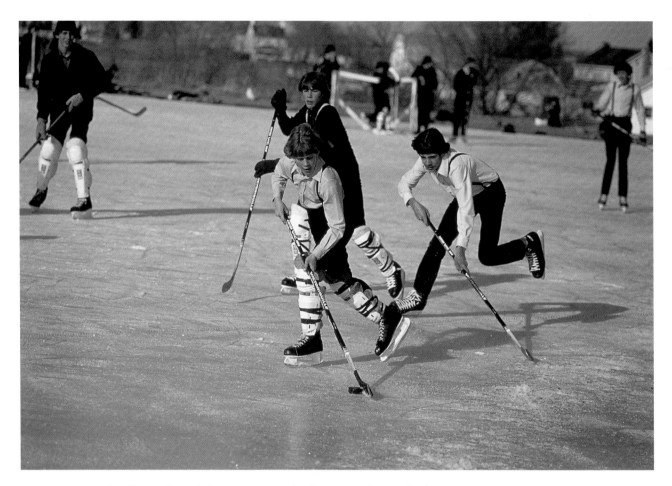

Farm ponds offer much-needed water in case of a fire—as well as ice hockey opportunities.

forever shape their future: deciding whether or not to be baptized and to join the Amish church. Baptism represents a lifelong commitment to the church, to the community, and to a particular way of living.

Parents and young people—and everyone else who cares deeply about them—know that "going with the young people" is also a small step away from full parental influence and authority. But it is a step all Amish children must take. It is movement toward the individual choice each child will make. It is also a move toward marriage.

Jake and Elizabeth, John and Sadie Mae will each join a "gang" this year. They will get together with their gangs each weekend, usually on Sunday evenings for supper and a singing, and for a volleyball game on those Saturday nights when they don't have church the next day. And by and by, as time goes on, members of the groups will start to pair up. It's meant to

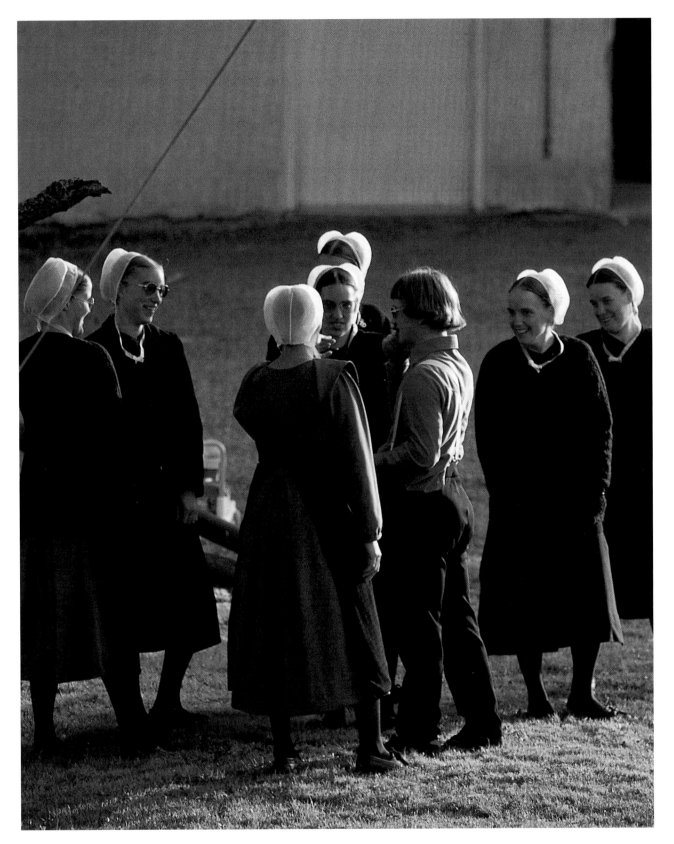

A break in a Sunday-evening singing.

be that way. Many Amish young people in the larger settlements find their spouses within their gang. In the end, they make their own choices, but they've been steered by their parents toward a gang both generations are comfortable with.

A Taste of Independence

A community which has invested so highly in the development of its children would be unlikely to leave its young people's major adult decisions to chance. Yet the wisest leaders and parents know that they can't finally direct their youngsters to join the church. Nor can they select their marriage partners. But the community does create as much momentum as possible.

Turning 16 does not come undetected or without preparation. Nearly every action and all the settings of these children's lives were designed as a background for this time. There is risk in these years, but the community has found a way to ease its children through them, with a mix of independence and embrace.

If the family owns a docile pony or a tame horse, and if they live along a lightly traveled road, boys and girls start to drive

A Sunday afternoon walk follows a three- to four-hour long church service.

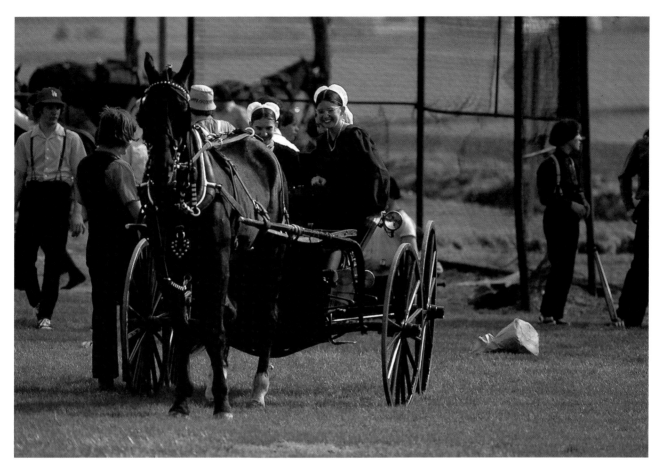

Young Amish women and men find each other at the ball diamond.

Try, Try Again

One day Dad said, "I think it is time to get the children a pony. They have to learn how to take care of animals."

Mother said, "Yes, I think that is a good idea. We could use the pony in the garden and the children could also drive it to get milk and eggs."

We children listened eagerly. "Oh, please, may we go along to the sale?" we asked.

"Yes, I think you may," said Dad.

At last the big day came. Big sister Naomi helped to pack the lunch for dinner. When the driver came, we all piled in. We could hardly sit still on the way. When we got to the sale barn, Dad looked to see which pony he liked best.

When the auctioneers started selling things, we went and sat down. Finally they sold the ponies and Dad bought the one he wanted.

We took the pony home and played with her. One day when William was riding her around the barn, he fell off. He was afraid. But he climbed back up and rode her again. He thought of how Dad always says to try, try again. The next time he stayed on.

— **by a ten-year-old** *(Blackboard Bulletin)*

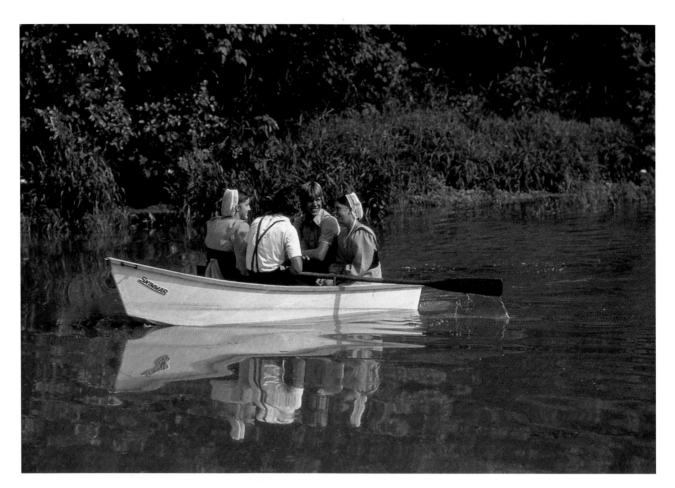

Double-dating on the neighborhood creek.

sometime between ages 11 and 14. "Usually they're driving by 14 so they can take themselves to vocational school and back," explains a mother of several driving children. "That way the parents aren't faced with providing the transportation, and then trying to figure out whether it's worth going back home while the children are in class, only to have to make the return trip soon again to pick them up."

In more recent years, however, children may be driving later. Highways, especially in the less rural areas, are crowded with fast-moving vehicles, adding considerable treachery to taking a horse and buggy out on the road's shoulder, or, worse yet, halfway into the lane of traffic.

Alternatives to Horses

"With the use of scooters and roller blades, driving is later, too," pointed out a mother of several adolescents. "The children have another, nearly-as-fast way to get where they need to go." Bicycles are not

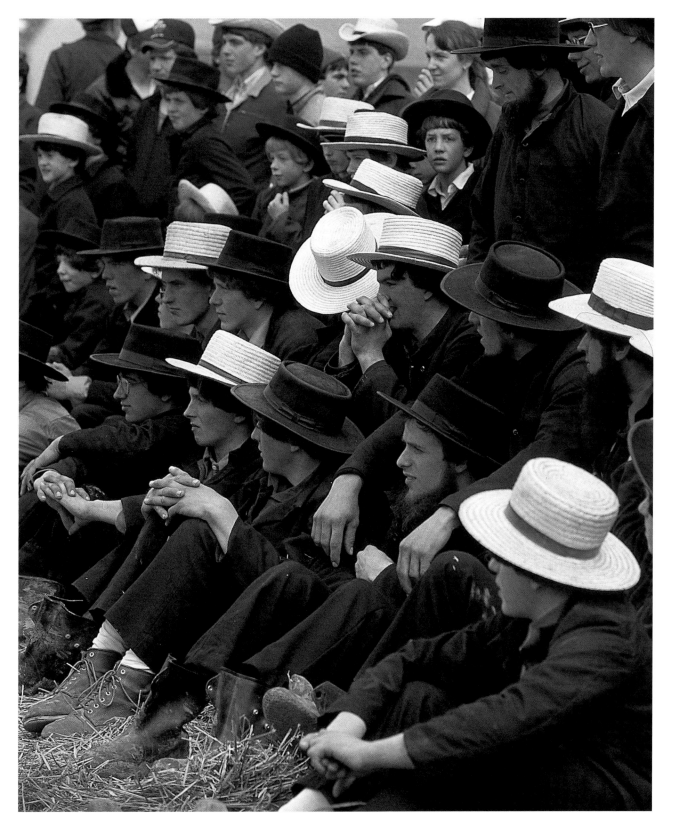

Spectators at a cornerball game.

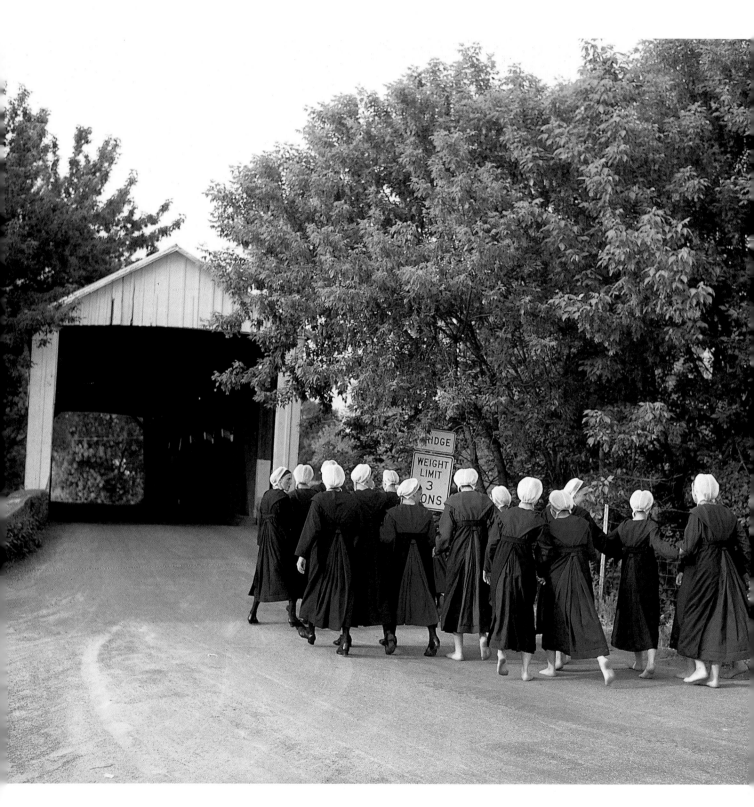

Members of a gang take a country-road hike to the covered bridge.

permitted in the Lancaster, Pennsylvania Amish areas because church leaders believe bikes allow their riders to travel too far from home. Scooters offer speed, but they're unlikely to be ridden as far as bikes. Roller blades, although a relatively new "convenience," have not been prohibited. They are not perceived to be threatening to the community. And so youngsters and younger adults fly along on smooth shoulders of roads, on their way to school, the neighbors, or work.

As more men are employed in nonfarming occupations, their children have less acquaintance with horses. "Those whose daddies aren't working around animals drive later, too," a mother observes.

No matter when they started to drive, boys at 16 receive their own horse, buggy, "and all that goes with it; the whole courting mechanism," smiles a

Off to a singing.

father. Before that, parents may supply a horse and carriage for their son's use. Sometime between 16 and 21, depending upon the family and their particular financial arrangements, the son becomes responsible for the horse's care (including its feed) and the buggy and harness' maintenance.

Going Out on Weekends

And then Sunday nights turn busy. The young people go out, gathering for singing and food and fun, often in someone's barn. There is design in these social groupings. Every young person joins a "gang" when they step out at 16, assuring that no one is overlooked when invitations are issued, or that individual couples don't wander off aimlessly without a planned activity. A "community" of peers welcomes and surrounds each young person on this move toward adulthood.

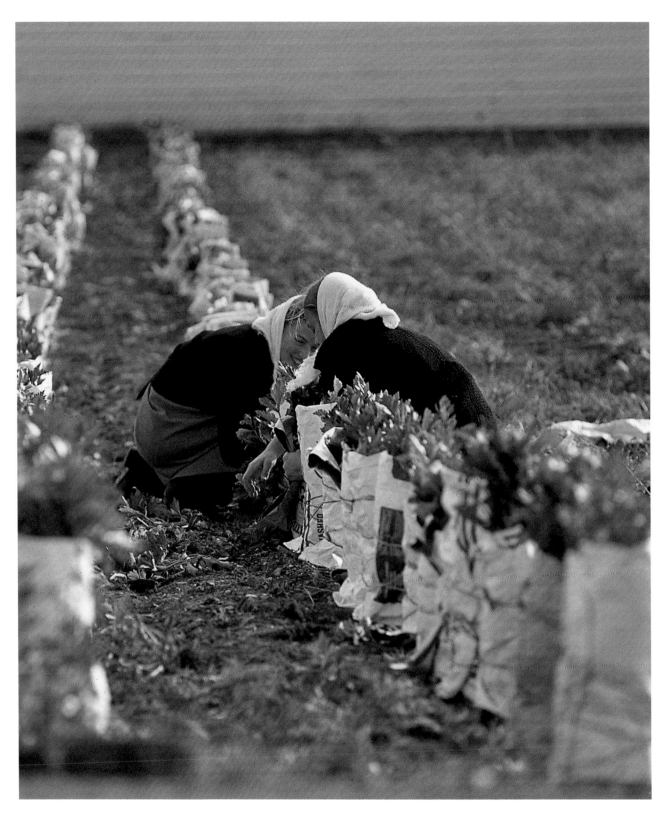

Creamed celery is traditionally served at Amish weddings. When a family plants a stand of celery, it's a clear signal that they have a daughter who is a bride-to-be. Two young women work in their family's celery patch.

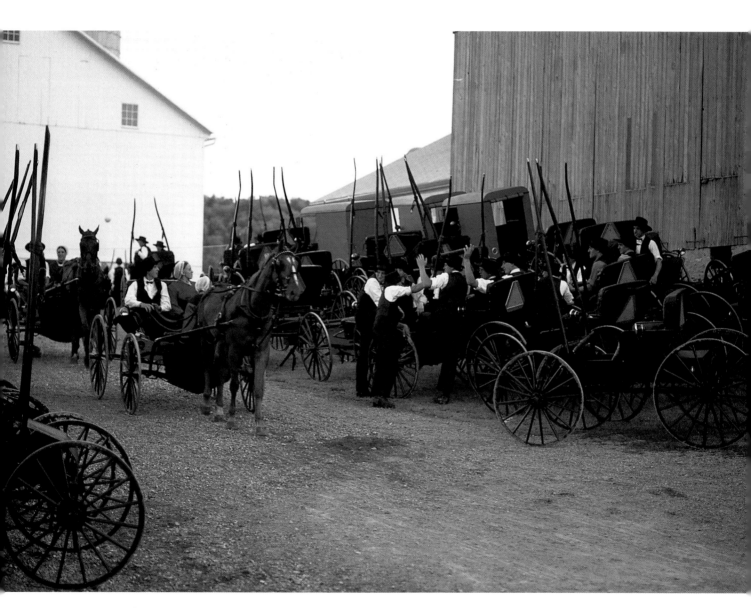

Leaving the farm parking lot of a young people's gathering.

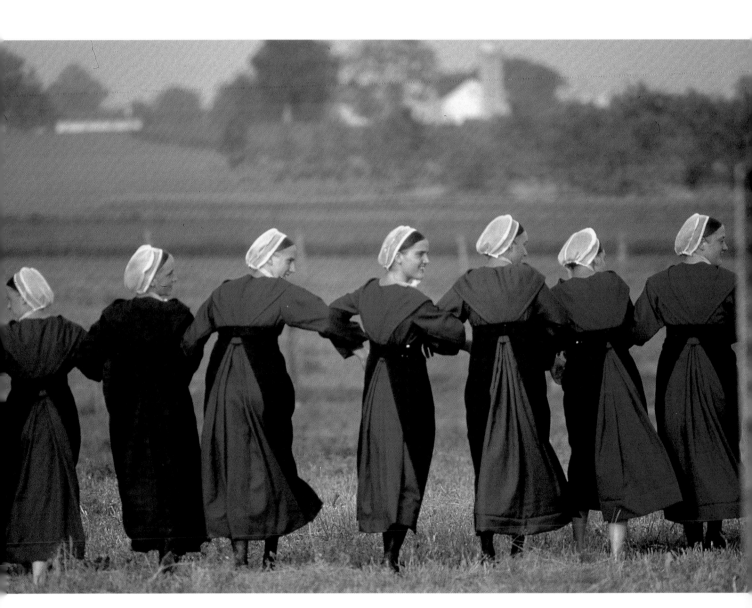

A rainbow of colorful dresses, all the more striking because Amish wear clothing made only of solid-colored fabric.

124

The gangs are big—70-150 people. They are given names—such as Kirkwooders, Pequea-ers, Chickadees, Cardinals, Crickets, Antiques, Pioneers.

They develop identities, indicating how wild or tame their behavior. They are usually half girls, half boys, allowing the opportunity for members to find their spouses within their buddy group.

In years past, buddy groups were extensions of friendship groupings that formed earlier in childhood. "When you turned 16 and started going to the singings and suppers, you had your group to be with. It just happened; you had a circle of friends that you were just with," describes an older man.

More recently, parents become deeply involved in matching their children with a group they believe to be suitable.

As Amish young people are released from their parents' direct supervision, they have opportunities to explore and experiment. Parents care deeply that their children not be influenced away from Christian faith and Amish principles. "More effort is given on the part of parents who are among the more 'liberal' of our people," comments one Amish leader. In more "traditional" families, parents tend to be hands-off; the more liberal-leaning are comparatively more involved with their children.

Since several Amish young adults were arrested for selling drugs in the late 1990s, many parents and leaders have become openly active in steering the young people for whom they're responsible toward trustworthy groups with upstanding activities. Too heavy a hand and the teenagers will spin out of the community; too much reliance on the strength of the old rules and the young adults may misstep without older adults noticing.

"Now more parents choose what group their children will attend," expresses one highly interested mother. "More parents are on the scene at the get-togethers

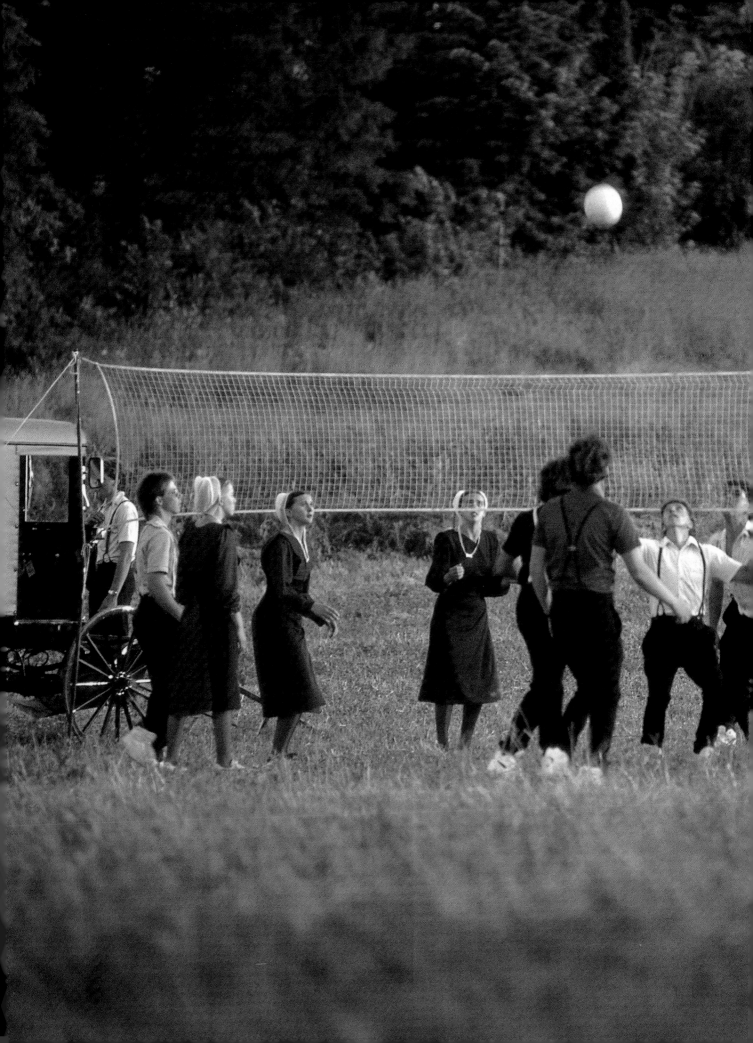

because of the way sports and vehicles and drinking have come in. And there are quite a number of groups for which those things aren't a problem at all."

Despite the aura of concern, the teenage years are highly anticipated. "It's a good time," smiles a mother of four young adults, all as yet unmarried.

Lots to Do

Social activities match the seasons. When it's too cold for setting up a volley-ball net in the meadow, the young people turn to indoor taffy pulls or skating.

Some take singing seriously, participating weekly in a "singing school." These informal sessions usually take place in the home of an adult prepared to teach music rudiments and sightreading. Traditional Amish singing in worship services is chant-like and slow, sung in unison in German. But young people turn to English and faster moving gospel-type songs at their Sunday night events. They want to be able to sing in four-part har-mony.

"Last season there were six singing schools around the area," explains the

A gang's Saturday night volleyball game in a meadow.

127

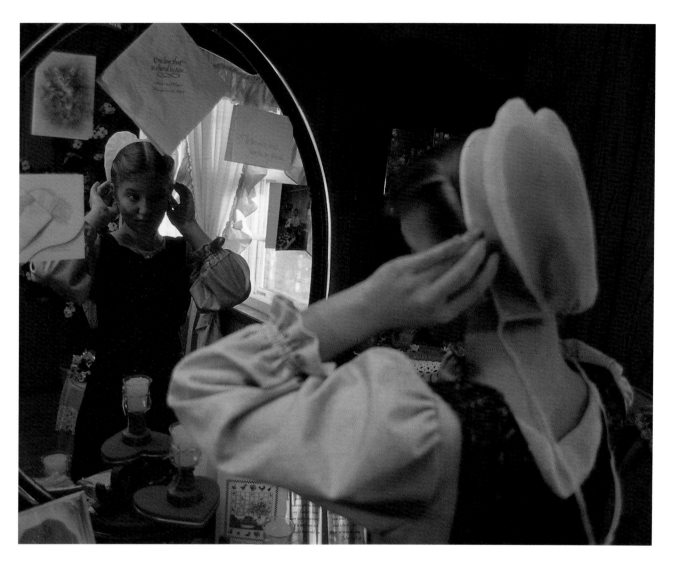

Surrounded by mementos and hints of her dreams, a young Amish woman prepares to go with the young people.

teacher of one, a young mother of four. "Each one meets for 10 or 12 weeks. Up to 40 young people may attend each of them, about half girls and about half boys. We sing from *Zion's Praises* (the favorite!) and also the *Christian Hymnary*. I teach them how to read shaped notes [a method in which each note of the scale is given a different shape on a musical score] and to sing scales.

"In addition to Sunday night singings, the groups often go together to sing for the sick or dying.

"A singing school group often disperses after members marry. But then some married couples get together later to keep up the singing!"

Accumulating for a New Home

While 16-year-olds begin a modest social schedule, a few signals at home also indicate their changing status. Young women receive a hope chest from their parents at about the same time. Into it go primarily linens—towels and bedding for a prospective new home. Sure to be among the pieces will be several quilts, made especially for her—and her own family in the future.

Later will come a china corner cupboard for dishes, usually "the summer before they get married," explains a bemused father. Of course, a girl receiving a "clock is a dead ringer that something's gonna happen!" Dating is a serious matter in the Amish world, yet lots of teasing surrounds a couple who seems headed for marriage but hasn't yet been "published"—the official announcement of their wedding plans by the deacon at the end of Sunday morning church. Couples are secretive about this very private and solemn step.

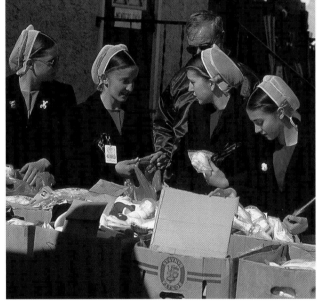

Sometime between ages 16 and 18, young men are given six books, all considered vital in an Amish home: the *Bible* (in German), the *Martyrs Mirror* (a collection of stories about persons martyred for their faith, primarily in medieval Europe), the "thick hymnbook" (the *Ausbund,* a collection of old hymn lyrics), the "thin hymnbook" (the *Unpartheyisches Gesangbuch,* used in singings), the *Christenpflict* prayerbook, and a *Lust Gärtlein* (a devotional book). These are the source materials for Amish life.

A boy also receives a desk at about this time, likely destined to become the "business" headquarters for his eventual household and farmstead. His mother and grandmother begin a stash of linens for him, usually making several quilts especially for him to take to his marriage.

Sports and Other Dangers

Those young people whose parents are not farmers have more unfilled hours than

A home. A gathering place. The primary site of most social events.

those who are needed constantly to keep a farm productive and presentable. Some teenage boys are forming or joining baseball teams that do not play casual pick-up games. They have a set playing schedule; they often play mid-week; they wear uniforms.

It's a development church leaders are watching. There's a limit to how much competition a community can bear. Nor may sports be permitted to become dominant, dictating, or even subtly shaping of

work and family life. In some districts, leaders and parents have already begun to curb the direction of these activities by permitting games but no uniforms.

This is an area that will undoubtedly require more wise vigilance as more Amish families earn their livelihoods in nonfarming occupations.

Alert to the powerful sway older siblings hold over younger ones—for both good and bad—one mother reflected, "It's easier to

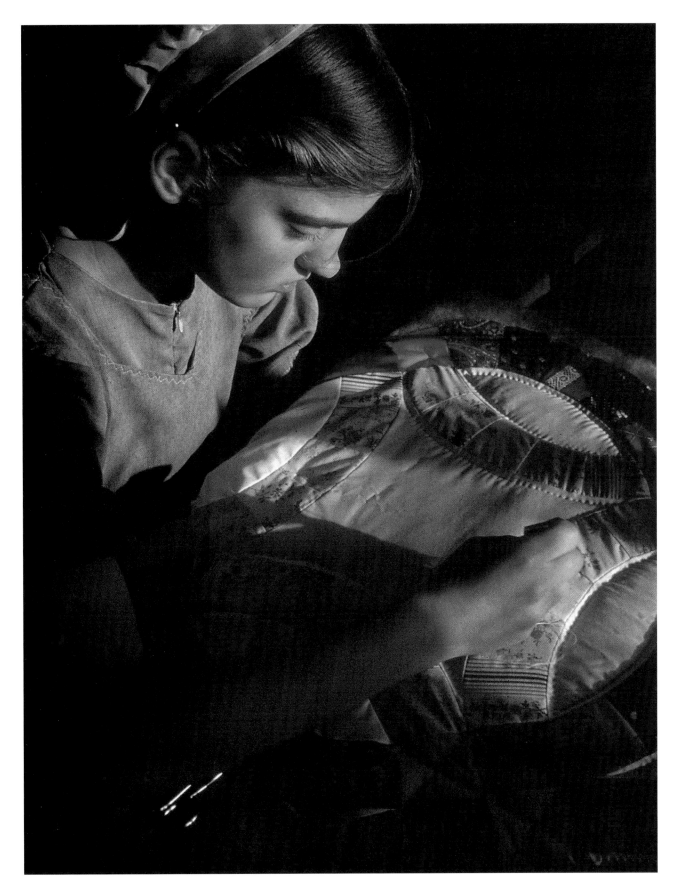

A Sunday Morning Scare

One Sunday morning when we sat down for breakfast, we discovered that my little brother Lester was missing.

"Go out and call him for breakfast," said Dad to Reuben.

Reuben went outside and called and called. He went through the outbuildings but did not get a response. Finally Dad went out to help look for him. Together they once again went through the chicken house and the shop, calling as they went. But still no Lester could be found.

Then they went to the barn again and called but could not see anything of the lost boy. Just as they turned to come back to the house, Dad heard a sleepy, "Wh-wh-a-at?"

Turning toward the sound, he saw Lester crawling out of a feed bag! He had been done with his chores so he had crawled into the bag to stay warm until the rest were done choring, and had fallen asleep inside the bag.

Although it was a bit late, we had a happy breakfast and trip to church after all.

— age 12, Scottville, MI *(Blackboard Bulletin)*

influence your Child Number One to choose a good group, than it is to influence your Children Two, Three, and Four, if Child Number One goes with a group you won't invite to your home because of all that goes on."

In the year 2000, there are 26 gangs in the Lancaster, Pennsylvania Amish communities. Three of those have been formed since the drug arrests a few years ago and are rather closely supervised by parents. "Our oldest son waited until he was 17½ to go with the young people," comments a concerned mother. "He didn't want to before then, and we didn't want him to.

"About 75% of the one new group are boys who voluntarily came to it. They did-

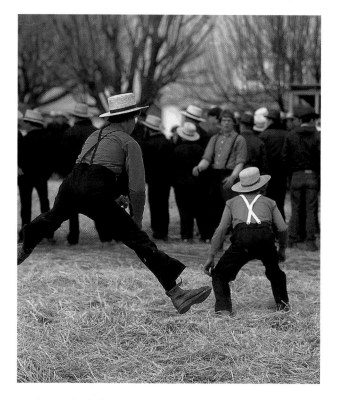

Dodging the ball.

n't want to participate in drinking and rock music and were afraid they might have if they had stayed. Now in the new group they're permitted to have gospel music and tapes in their vehicles. Of course, these are ones who haven't joined the church yet."

It is a test for all involved, not the least of whom are Amish parents and leaders, allowing their children to have a small taste of the "world" before they decide to give their lives to the church and its highly articulated expression of community.

"I'm more hopeful," says the mother whose son delayed going with the young people until he had an appropriate option. "With the start of these new youth groups, I'm excited again about our children joining—and reaching this age. We know that they're with young people whose parents have the same values."

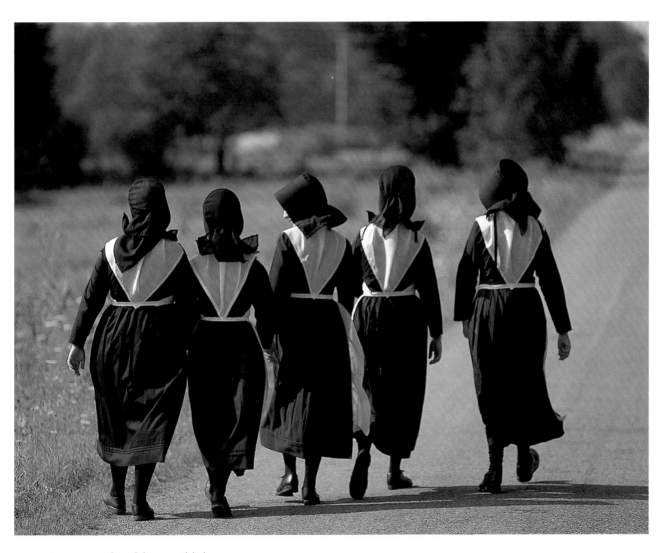

Security in friendships and belonging.

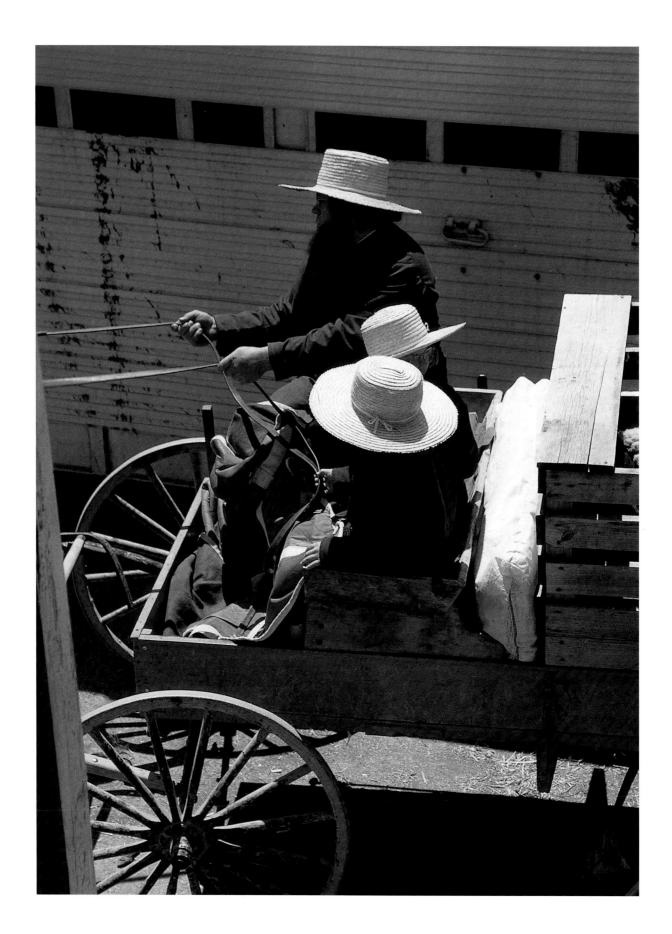

134

JOINING THE CHURCH

Joining the church is not a sudden decision. Amish children are prepared for this critical choice from birth. They have a home in this community from the beginning; they come to know they have a place there.

Yet becoming a member of the church is not automatic. Choosing to be baptized and

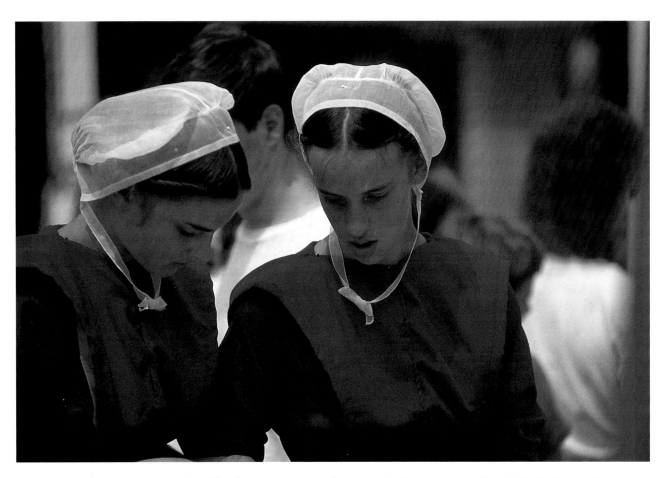

(Above): Belonging is reinforced by sharing a common language, by dressing in an identifiable clothing style.
(Left): Children and parents spend many daytime hours together.

135

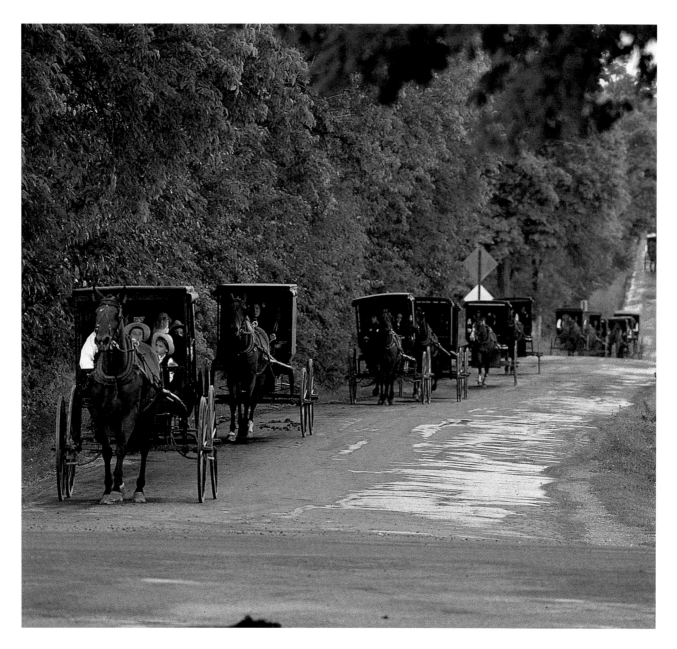

The neighborhood, en route to church.

to join the church is a decision for one's late teens or early 20s. It is meant to be a voluntary adult decision.

Without a doubt, parents and the Amish community as a whole do their best to make church membership, and all that surrounds it, a desirable opportunity. They so immerse their children and young people in their way of life that they may seem not to have the means to consider alternatives.

Granted, Amish children and young adults have limited exposure to the larger

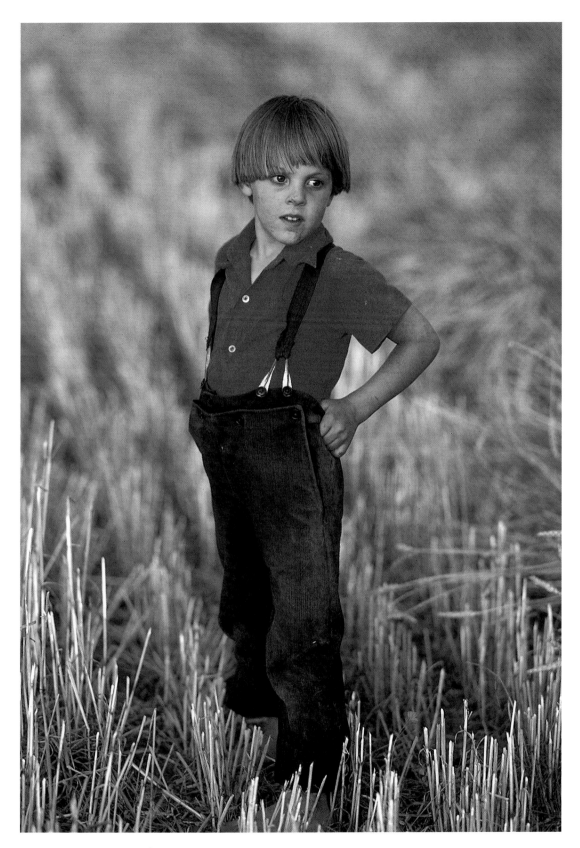

Taking in the present. Or imagining the future.

world. But they are keen observers. These children are not brought up in a monastic setting, removed from exchange with others. While the Amish way seems to be all-encompassing (from language to clothing to transportation to the use of time), it has some flexibility, some openings, for youngsters to look beyond their defined world.

Looking Around

During those in-between years, from the mid- to late teens, young people spend more time away from parents (and teachers and neighbors) than ever before. Their weekend social events are not usually supervised by adults. In addition, some take jobs away from home that put them in touch with the public, whether or not they work for an Amish employer.

Amish parents and leaders sense intuitively that, although they have provided a sheltered environment for their children, they cannot prevent them from some exploration; they cannot force them to join the church.

Before they are baptized and become church members,

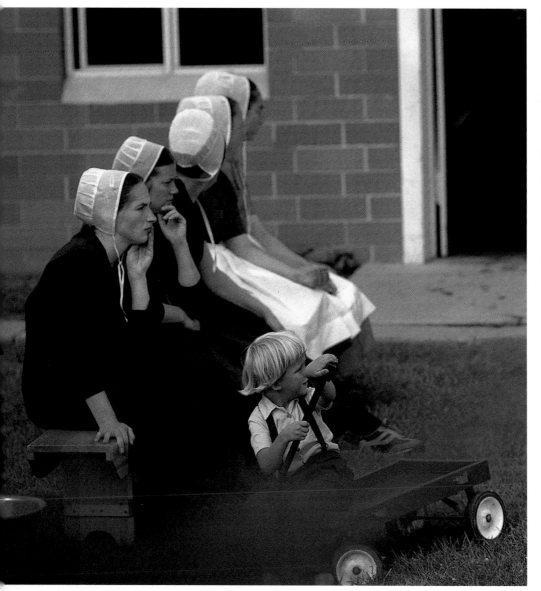

Farm auctions, family reunions, Sisters Days— all bring women and children together.

138

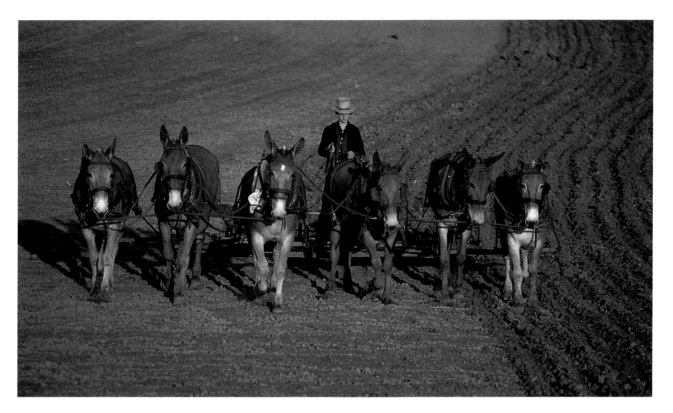

Young people are dignified when they're entrusted with responsibility for which they've been prepared.

Haste Makes Waste

Amos walked briskly home from school. Tonight he had planned to finish the bluebird houses. He was in a hurry and didn't wait on the girls.

He clamped one board in the vise and laid another on it in a correct position. It didn't take him long to finish his first bluebird house because he had already started it the evening before. Amos was just ready to start on his second one when Dad called, "Time to feed the cows."

Amos stuck the half-finished birdhouse under the bench and went out to feed the cattle. He fed the cows as fast as he could and then returned to the shop.

Amos tried to put a nail through a knot in the board. The nail refused to go through. It made him feel impatient because he knew he should be out in the barn doing his chores. He gave the nail an extra hard whack. The hammer slipped and landed squarely on his finger.

After a while the pain lessened so he went out to the barn. Meekly, he grabbed a milk stool and started milking. His finger hurt too much so finally he told Dad the whole story.

For a few days the finger was very sore. Amos decided that he would try and remember to stop his projects when it was chore-time and not try to push it and do just a little more.

— **Joas Bontrager, Grade five, age 11**
(Blackboard Bulletin)

139

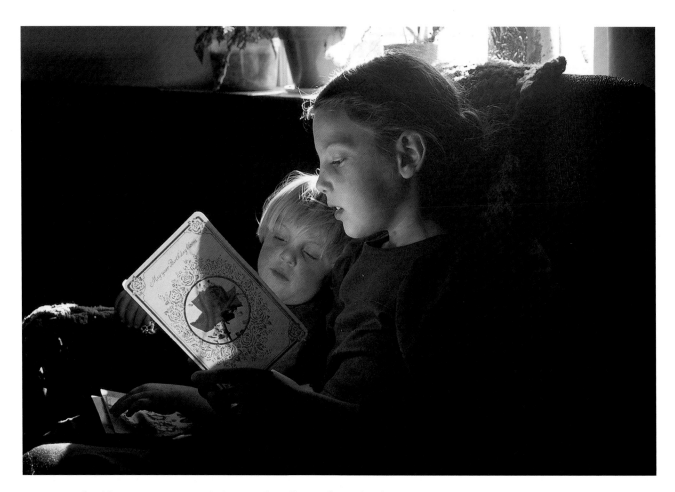

Amish siblings can spat—and show tender affection for each other.

some Amish young people own cars or trucks, enjoy live bands at their barn parties, see movies on occasion, and experiment with smoking and drinking. For the majority, these forays into "worldly" activities end relatively quickly. While a troubling time for parents, this valve seems to permit young people to make a freer choice about their futures. Allowed some dalliance with unacceptable practices, they appear more prepared to commit themselves fully to the church and its expectations.

While this behavior is not sanctioned, Amish adults pray, stay attentive, and find support from each other. "Oh, yes, moms talk together," smiles a young mother whose children are still safely within her care. "Parents worry about the teenage years. They hope their children stick to the 'straight and narrow.'"

Steps Toward Baptism

Young persons who have decided to be baptized seek out a church leader to

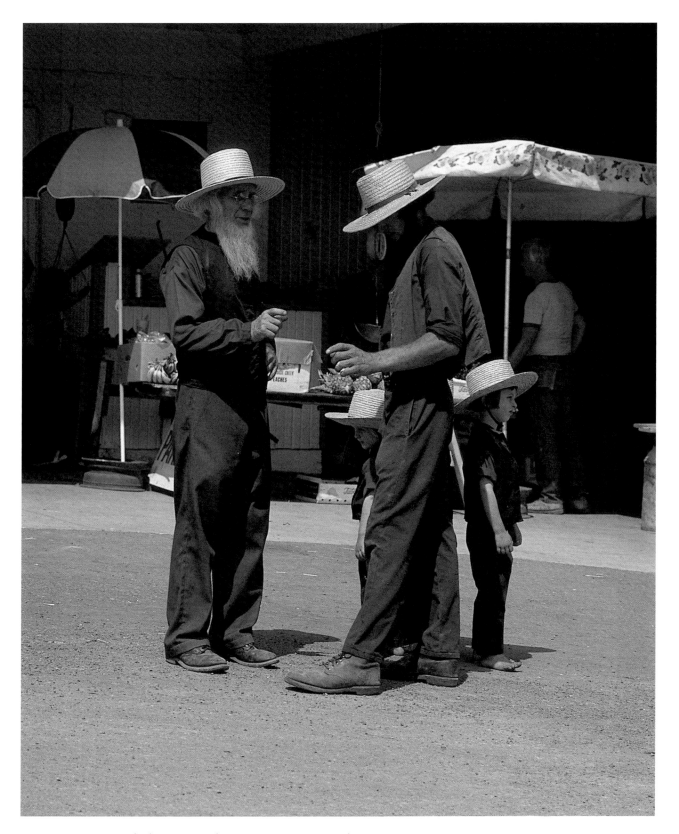

Going to town for business is also a two-generation social occasion.

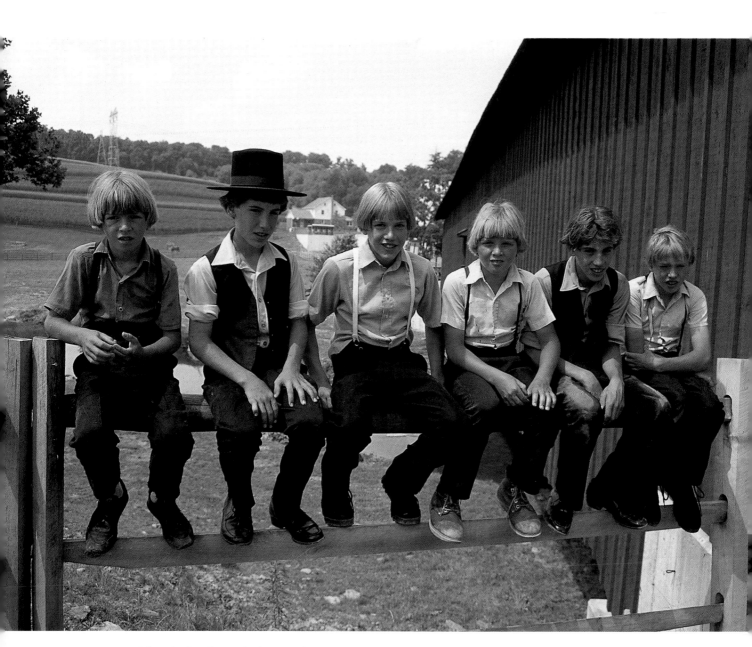

Good friends, hatching who-knows-what.

express their wish privately. Following that, they join an instruction class which meets for nine sessions, each one prior to the biweekly Sunday-morning service. The content of those meetings is well established. They cover the 18 articles of the confession of faith which states the basic beliefs the Amish hold. (This statement was agreed to in 1632 in the Dutch city of Dort and highlights key doctrinal matters from creation to redemption to the life of the church. It is often referred to as the Dordrecht Confession of Faith.) In addition, the *Ordnung*, or the church's expectations for living, is reviewed.

Along the way, the members hold a meeting at which time the leaders announce the applicants and ask if the members are prepared to receive them. It is not unusual for older members to

A growing certainty about who she is.

express advice or encouragement. (Specific objections are rare.)

Baptism is held during a regularly scheduled Sunday morning preaching service. Applicants are asked to answer three questions: whether they believe in God the creator, Jesus the savior, and the Holy Spirit as sustainer; whether they have repented of their sin and are willing to forsake their own will; and whether they will follow Christ's teachings until they die, by God's grace and guidance.

A Commitment Forever

When the young persons have made their public confessions they kneel, and the bishop and deacon pour a small stream of water on each applicant's head, pronouncing each to be "baptized with water, in the name of the Father, Son, and Holy Ghost."

143

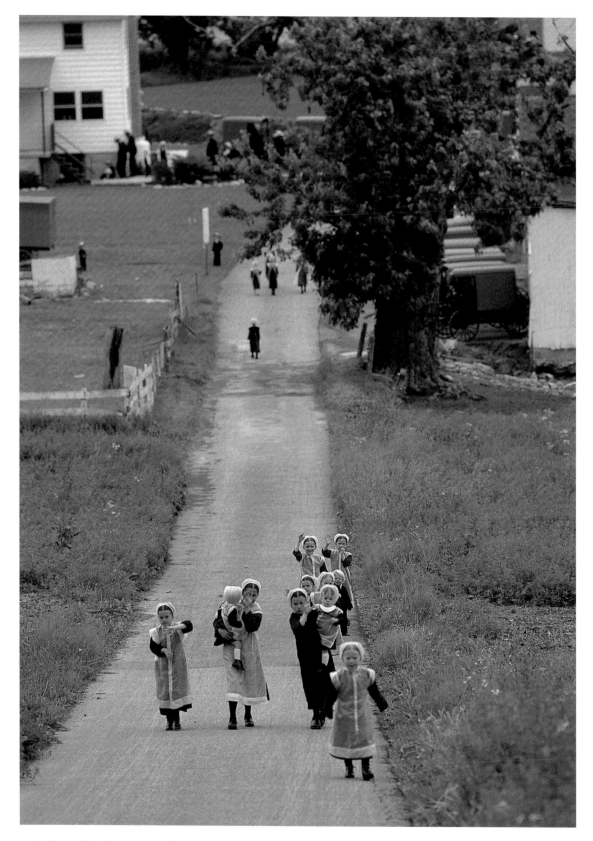

Church and lunch are over; the young women explore the farm lane and where it heads.

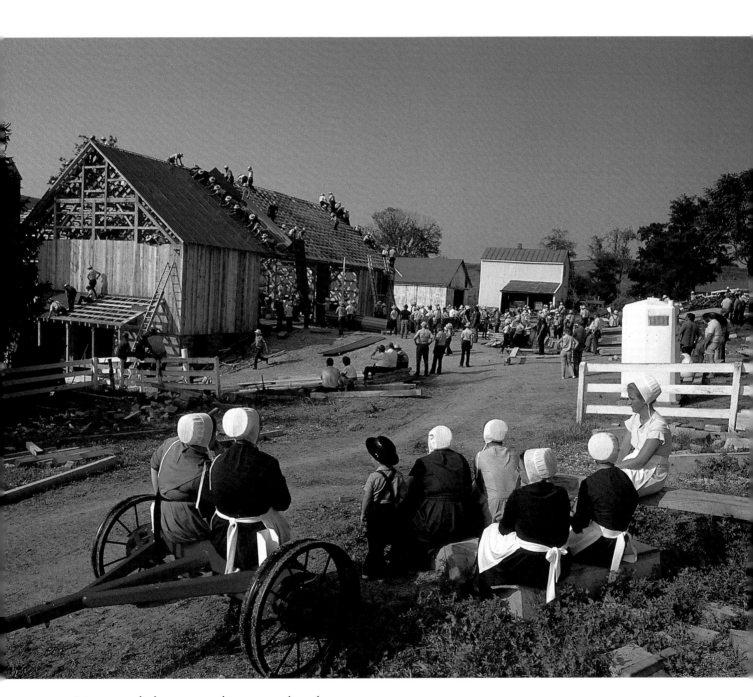

A moment of relaxation in otherwise very busy lives.

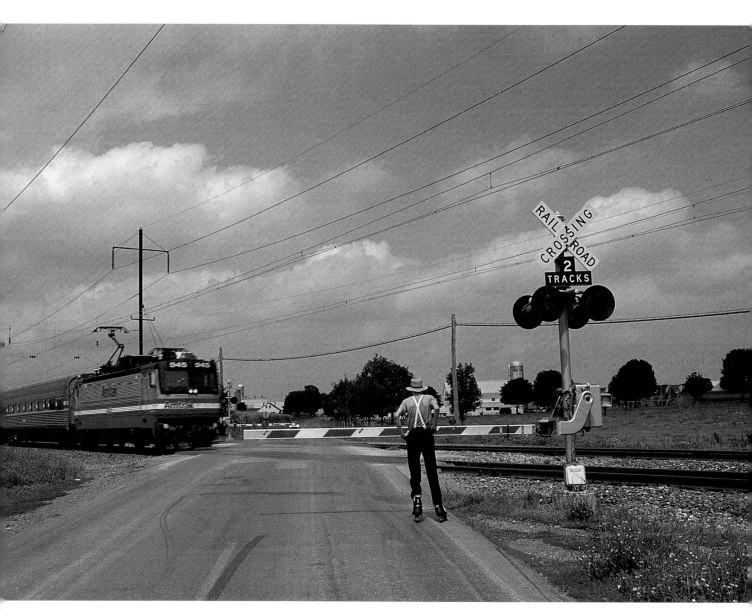

Amish young people lead defined, but not confined, lives.

146

The bishop then takes the right hand of each, one by one, invites each to stand, and "welcomes [them] as a brother/sister in the congregation." These young persons' commitment to faith and the Amish way of life has been made forever. They take their vows seriously, fully intending to live faithfully and obediently. This action signals the end of any borderline behavior, any thoughts of finding a life outside the community.

The Beginning of Adult Life

An Amish child has become an Amish adult, prepared to take his or her place as a fully contribut-ing member of the faith commu-nity. And mar-riage is likely not too far away.

It is a solemn moment, but these young peo-ple have not stepped off into some vast unknown. Each has made a per-sonal choice, but, as always, each is accompanied by others, visibly and surely. Their decisions come as a result of watch-

ful but gentle parenting, of an interested and ever-present community.

"If children feel secure as a family, if they see godly principles working in their parents' lives, they're more inclined to fol-low their direction," observes a mother of seven, ages seven to 21.

"When you see that your child or teenager has something on his mind, take time to discuss the problem and explain as much as you can," counsels a grandmoth-er.

One grandfather was glad to be ignored at the table: "My five granddaughters and their parents were talking at Monday lunch and laugh-ing about Sunday goings-on—and they didn't even know I was there! I thought to myself—there's a good bond between parents and children!"

Another grand-father describes an Amish adult's responsibility to an Amish child simply and directly: "Watch and pray and try always to be con-sistent. Be firm but not harsh, and whatev-

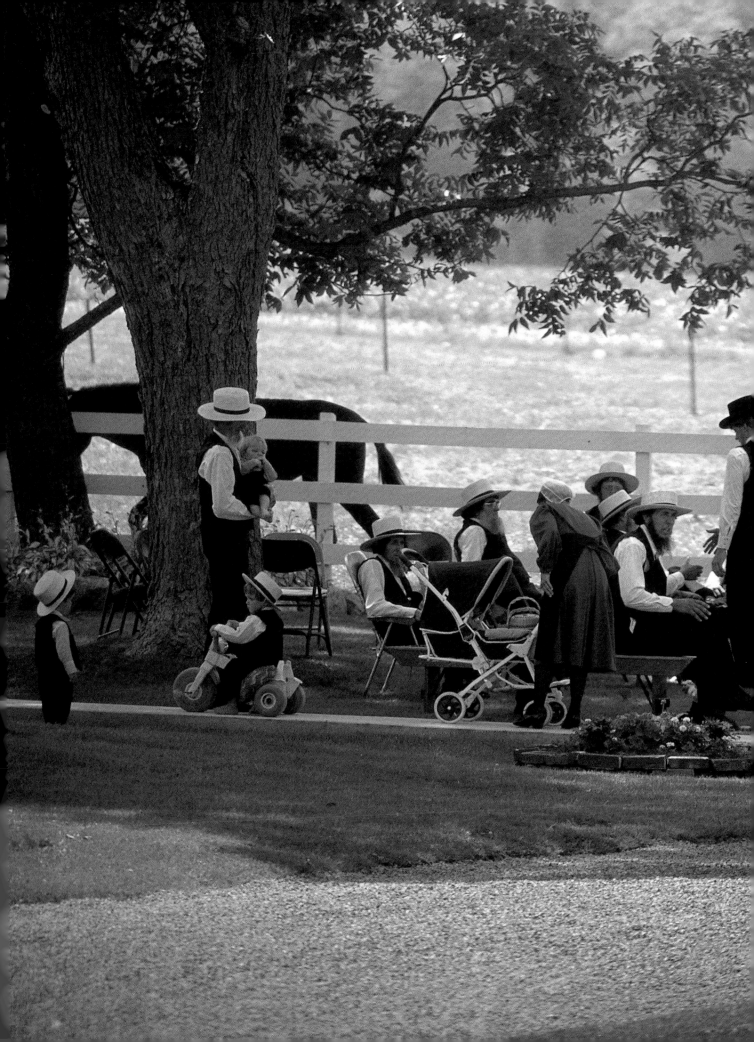

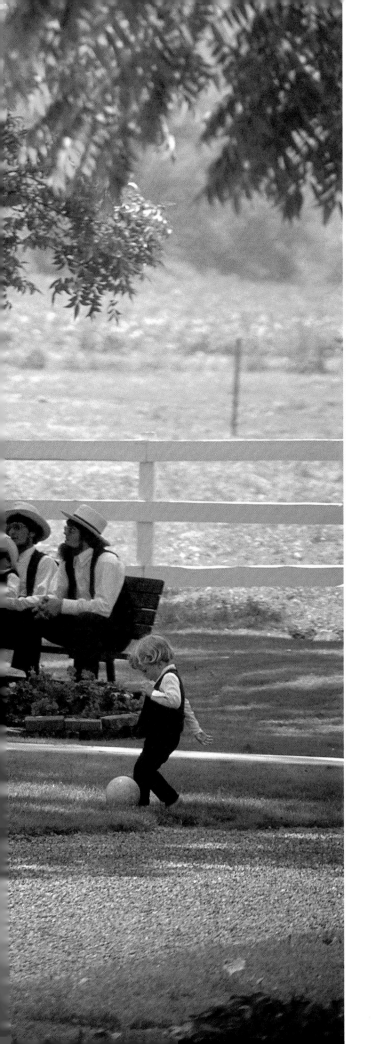

er you do, let love be your guiding motive. The greatest need is to be a good example."

These newly baptized Amish young people likely have thoughts of marriage on their minds already. And soon after that, children. Amish children. And so, the community goes on.

The Amish take time to visit, a skill they model continually for their children. After church, and before the afternoon milking, is a cherished time for all ages.

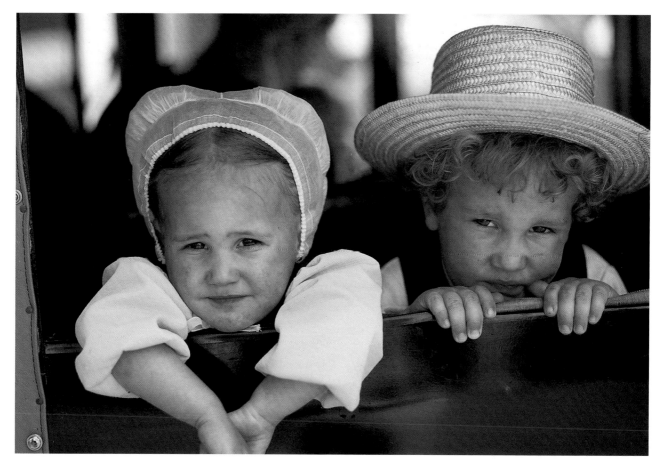

Amish children are given a place to belong.

150

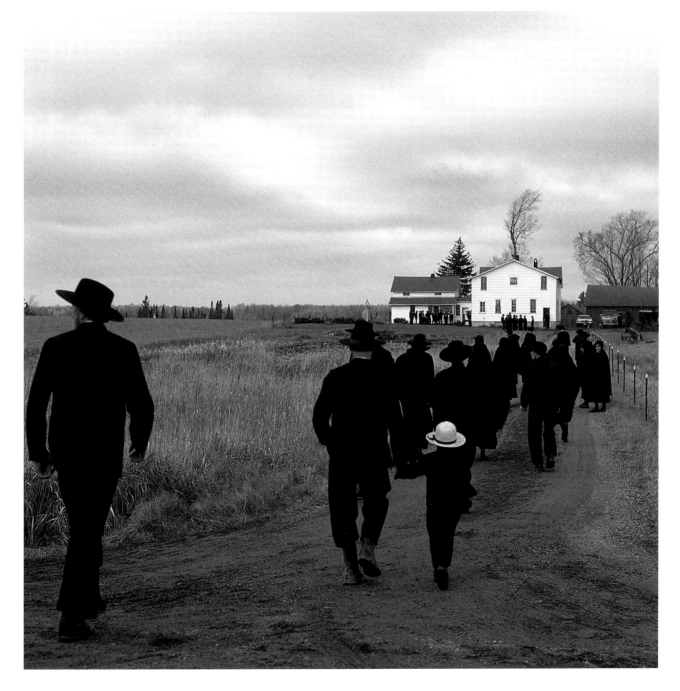

151

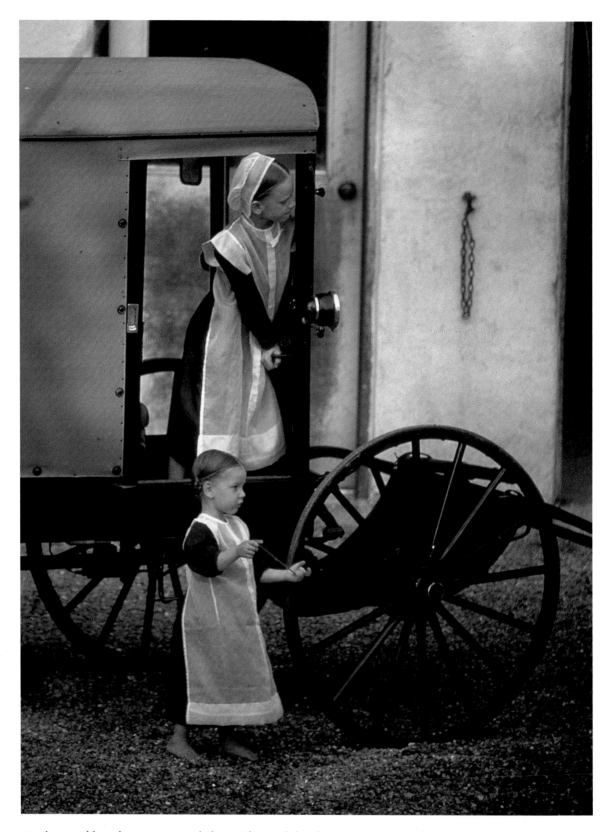

(Right): Wedding day on an Amish farm. The porch has been enclosed to accommodate an overflow crowd of family and friends who have come to witness two recently baptized young people move firmly into adulthood.

Readings and Sources

Blackboard Bulletin. Amish periodical published monthly. Pathway Publishing House, Aylmer, ON.

Budget, The. Sugarcreek, OH. A weekly newspaper serving the Amish and Mennonite communities.

Devoted Christian's Prayer Book, A. Pathway Publishers, Aylmer, ON, 1967.

Family Life. Amish periodical published monthly. Pathway Publishers, Aylmer, ON.

Fisher, Sara E. and Rachel K. Stahl. *The Amish School.* Good Books, Intercourse, PA, 1997.

Glick, Aaron S. *The Fortunate Years: An Amish Life.* Good Books, Intercourse, PA, 1994.

Good, Merle and Phyllis. *20 Most Asked Questions About the Amish and Mennonites.* Good Books, Intercourse, PA, 1995.

Good Merle and P. Buckley Moss. *Reuben and the Blizzard.* Good Books, Intercourse, PA, 1995.

_____, *Reuben and the Fire.* Good Books, Intercourse, PA, 1993.

_____, *Reuben and the Quilt.* Good Books, Intercourse, PA, 1999.

Good, Phyllis Pellman. *Plain Pig's ABC's: A Day on Plain Pig's Amish Farm.* Good Books, Intercourse, PA, 1998.

Good, Phyllis Pellman, Kate Good and Rebecca Good. *Amish Cooking for Kids.* Good Books, Intercourse, PA, 1995.

Hostetler, John A. *Amish Society.* Johns Hopkins University Press, Baltimore, MD, 1993.

Hostetler, John A. and Gertrude E. Huntington. *Amish Children: Education in the Family, School, and Community.* Harcourt, Brace, Jovanovich College Publishers, 1992.

Kaiser, Grace. *Dr. Frau: A Woman Doctor Among the Amish.* Good Books, Intercourse, PA, 1997.

Keim, Albert N. *Compulsory Education and the Amish.* Beacon Press, Boston, MA, 1975.

Kraybill, Donald B. *The Puzzles of Amish Life.* Good Books, Intercourse, PA, 1990.

Miller, Levi. *Ben's Wayne.* Good Books, Intercourse, PA, 1989.

Nolt, Steven. *A History of the Amish.* Good Books, Intercourse, PA, 1992.

Oyer, John and Robert Kreider. *Mirror of the Martyrs.* Good Books, Intercourse, PA, 1990.

Scott, Stephen. *The Amish Wedding & Other Special Occasions of the Old Order Communities.* Good Books, Intercourse, PA, 1988.

_____. *Why Do They Dress That Way?* Good Books, Intercourse, PA, 1986.

Stoltzfus, Louise. *Amish Women: Lives and Stories.* Good Books, Intercourse, PA, 1994.

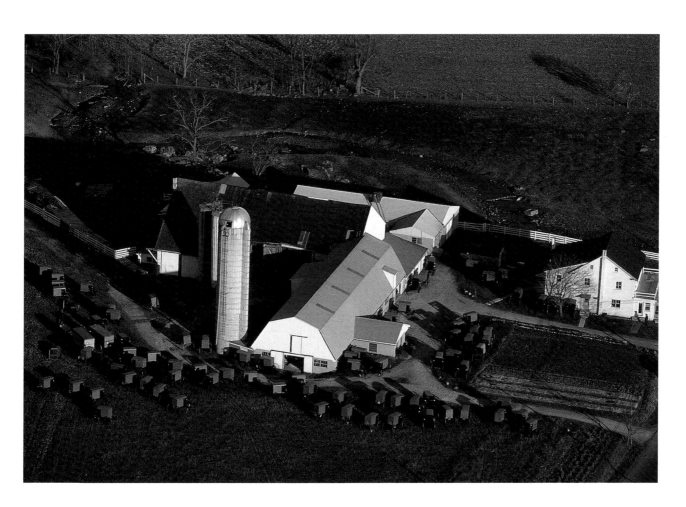

About the Author

Phyllis Pellman Good, Lancaster, Pennsylvania, is a *New York Times* bestselling writer who has authored many articles and books about Amish life.

Good has authored or co-authored more than 50 books, which have sold more than 2,500,000 copies. Among her books related to the Amish are ***The Best of Amish Cooking, Quilts from Two Valleys: Amish Quilts from the Big Valley, Mennonite Quilts from the Shenandoah Valley***, and a children's book ***Plain Pig's ABC's: A Day on Plain Pig's Amish Farm***. She and her husband Merle co-authored the bestselling ***20 Most Asked Questions About the Amish and Mennonites***.

The Goods have teamed together on numerous projects through the years. They are executive directors of The People's Place, The Old Country Store, and The People's Place Quilt Museum, all based in the Lancaster County village of Intercourse, Pennsylvania.

About the Photographer

Jerry Irwin is a freelance photographer who has specialized in Amish subjects for much of his lengthy career. He gained the respect and the trust of the Amish after living for more than 20 years on their homesteads and as their neighbor.

Irwin's photographs have appeared in publications around the world, including six books and numerous magazines. Among the periodicals that have featured Irwin's photographs are ***Sports Illustrated, National Geographic, Country Journal, National Geographic Traveler, Washington Post Magazine, Harrowsmith***, and ***Geo***.